PATRIOTIC
CIVIL WAR TOKENS

PATRIOTIC
CIVIL WAR TOKENS

A descriptive and price catalogue
of the die varieties of patriotic type tokens
used as a substitute for money during the
American Civil War.

GEORGE AND MELVIN FULD

QUARTERMAN PUBLICATIONS, INC.

Lawrence, Massachusetts

© 1965, 1960 Western Publishing Company, Inc.
Third Revised Edition
Reprinted by permission

This work is a facsimile reproduction of the Third Revised Edition published in 1965 by Whitman Publishing Company in Racine, Wisconsin. The Plates of tokens illustrated in this edition have utilized original photographic materials produced circa 1959.

International Standard Book Number: 0-88000-128-3

Library of Congress Catalog Card Number: 81-51603

Printed in the United States of America

Quarterman Publications, Inc.
5 South Union Street
Lawrence, Massachusetts 01843

Patriotic Civil War Tokens

IN 1965 was concluded the celebration of the Centennial of one of the most famous conflicts of modern times, the American Civil War. From a numismatic point of view the Civil War gave rise to many innovations in currency as well as various emergency specie. No short period in our history has produced such wide changes in our monetary system. The first official Government greenbacks as well as the extensive series of fractional currency (shinplasters) were issued during the War. The paper money of today is such an essential part of our everyday life that it is hard to realize that it is not yet one hundred years old. Towards the end of the War the two cent pieces were issued, as well as the first use of the now familiar motto "In God We Trust." The first bronze Indian head cents were issued as patterns in 1863 and achieved general circulation in 1864. All these sweeping changes have had a lasting effect on our monetary systems.

Likewise, the Confederacy issued numerous forms of paper currency which, until very recently, never received the attention they deserve. The metallic issues of the Confederacy, although not numerous are a very important reminder of Confederate history.

In addition, the Civil War gave rise to numerous forms of emergency specie, the variety and ingenuity of which have never been been equaled. Early in 1862 all metallic currency was gradually withdrawn from circulation. Citizens, anticipating the possible increase in the value of all metals, commenced hoarding gold, silver and even copper to such an extent that there were no metallic coins in circulation. One can imagine the chaos that was created in the conducting of everyday business. There was no way to make change and the merchants were forced to resort to some means of promoting a method of exchange. The first attempt at making change was the use of the ordinary U.S. postage stamp. Obviously, because of their flimsy nature, these stamps had a very short circulation life. Next, the merchants issued small envelopes, generally with an advertisement on them, so that the stamps could obtain some degree of protection. In 1862, John Gault patented a novel brass encasing for the stamps, with a mica cover so that the stamps could readily be visible. These encased postage stamps, manufactured by the Scovill Manufacturing C^ in Waterbury, Conn. with merchants' advertisements on one side widely circulated in denominations from one to ninety cents. But these encased stamps had one disadvantage, they cost too much to issue since the stamps still cost their face value.

In addition various forms of fractional, privately issued paper currency appeared, but because it had so little intrinsic value, it did not meet wide acceptance. Cardboard scrip was also circulated. However, the most popular and realistic form of emergency currency took the form of small copper coins, generally in imitation of the Government currency, which first circulated in Cincinnati late in 1862.

These small copper coins, generally the size and weight of the

small bronze cent, met with general acceptance. In the spring of 1863 the Lindenmueller currency was issued in New York City—a million pieces being struck. William H. Bridgens then issued the Knickerbocker currency, in many varieties in large quantities.

Two general types of tokens were issued — the so-called patriotic tokens and the tradesmen's cards. The patriotic series, mainly issued in and around New York, had patriotic slogans on the coins, but bore no merchants' advertisements. Many of the pieces were in general imitation of the Indian cent then currently popular. The present article will deal only with the patriotic series, of which over 1500 varieties will be listed. The merchant's or tradesmen's cards were widely issued and bore, in general, the merchant's advertisement on one side and some patriotic symbol on the other. These tradesmen's tokens were issued in 23 states and almost 300 towns, mostly in the North with a few issues from the border states. These pieces will not be covered in the present work, but will be the subject of a separate treatise. There are over 8500 different tradesmen's tokens known, some 5800 of them being listed by Hetrich and Guttag.

The issue of Civil War tokens far exceeded 25,000,000 pieces which amply filled the needs of the merchants. They were commonly accepted as a means of exchange for the value, which was usually one cent. It should be mentioned that merchants could make a tidy profit using these coins, as the copper value in them was only 23/100ths of a cent. They were undoubtedly a source of great relief and convenience but their irresponsible character soon attracted the attention of the Federal Government.

Hetrich and Guttag stated that the Third Avenue Railroad of New York requested Lindenmueller to redeem a large number of his tokens, which they had accepted in the course of business, but this he laughingly refused to do. The railroad had no redress, and it is likely that incidents such as this forced the hand of the Government. The attempts at issuing the bronze cents and fractional currency were not sufficient to suppress the Civil War tokens then current. Finally in 1864, an act of Congress forbid any private individuals to issue any form of money. Thus ended an era—one that has been slow to be recognized by numismatists.

The recent upsurge of interest in this series has attracted attention to the Civil War token, but collectors have been handicapped by the lack of a readily available, easy to follow, check list of the numerous varieties of Civil War cents. The authorative book on this subject has long been Hetrich and Guttag's epic work, "Civil War Tokens and Tradesmen's Cards." This book, published in 1924, long out of print and virtually unobtainable, went a long way towards creating order out of chaos. However, while Hetrich and Guttag listed only some 7000 varieties of tokens, at present there are over 11,000 different specimens authoritatively reported. Joseph Barnett made extensive revisions of the H and G work in a series of articles in The Numismatist in 1943 and 1944 and in The Numismatic Review of 1945. However, because of the many new dies, and sub-varieties necessitated by the adherence to the Hetrich and Guttag system, much confusion has arisen. As the revision of a list of over 11,000 different coins is such a complex undertaking, the authors have conveniently divided the series

into the Patriotic pieces, which bear no advertising in reference to any particular firm, and the Tradesmen's Cards which have advertising. Recently, the late Raymond Haggenjos, in the **Numismatic Scrapbook Magazine** revised the Indiana Civil War tradesmen's cards, and this will be continued by the authors on a state by state basis as rapidly as possible.

Perhaps the first attempt at a compilation of Civil War tokens appeared in the **Journal of the American Philosophical Society** in 1863. This little known contribution by Pliny E. Chase listed some 303 varieties of Civil War tokens. The next listing of these tokens appeared in the **American Journal of Numismatics** commencing in June of 1866 under the title of "**Copperheads.**" This list appeared spasmodically until July, 1869 but unfortunately was never completed. The list contained over 700 varieties but never was extended to the Patriotic or Mid-Western series.

The next comprehensive coverage was made in the **Coin Collector's Journal** during 1882 and 1883, and was founded chiefly on the famous Groh collection at the American Numismatic Society, which originally consisted of 5600 different pieces. (The Society's collection has been considerably expanded over the years by many contributors, to where it is estimated it now contains over 8000 different specimens.) This list made the basis for the first illustrated work on Civil War tokens by Edgar H. Adams, which was published in the **Coin and Medal Bulletin** from April, 1916 to March, 1917. Unfortunately, the **Bulletin** was discontinued before the series could be completed.

Adams' articles formed the basis upon which the famous Hetrich and Guttag book, "Civil War Tokens and Tradesmen's Cards" was published. The system used for identifying the coins in the present work is based on the original ideas of Messrs. Adams, Hetrich and Guttag. All the dies that are represented on the coins are numbered consecutively, in the present work from 1 through 521. These pieces are grouped together, with what is commonly called the obverse side (or heads) of the coins being grouped first. A strict adherence to this is not possible because the dies were used in many combinations, making any clear-cut distinction between "heads" and "tails" meaningless. Thus, in the ensuing list when two dies are mentioned in combination, the lower numbered one is called the obverse and the higher numbered one is called the reverse.

The ensuing list is arranged as follows: In the first column appears the number of the obverse, as shown exactly on the plate. The second column gives the reverse, an illustration of which can also be found on the plates. The next column gives the abbreviation of the metal in which the piece was struck, the fourth column gives an estimate of the rarity of the coin, while the last column gives the original Hetrich and Guttag number assigned to the piece. Various remarks such as references to other works such as Baker and King as well as overstrikes are given in a line immediately below the coin description. No attempt has been made to give the Hetrich and Guttag number where it did not originally appear in their book. Thus there are no direct references to the extensive articles of Joseph Barnett or the several specialized articles by the authors which assigned new H and G numbers to the coins. This is because what one collector may call 104A, another may

have called 104½, etc. Thus, to avoid confusion, all pseudo H and G numbers were not referred to in the present work.

Coins are not denoted by a simple number, which would confuse the listing with the H and G listing and does not allow suitable flexibility. Thus, instead of referring to a coin as H and G 698, it is now referred to as **125/294 WM**. This system has several advantages. First, most new varieties that have and will continue to be found since the publication of Hetrich and Guttag will be either metal variations or new combinations of presently known dies. Thus, there will be no disordering of coins, when new varieties are added unless a new die is discovered, and it can then be referred to as an "A" variety of the die most closely resembling it. This has been necessary in several cases by accidental omission and a few last-minute discoveries while the manuscript was being assembled. These pieces are shown on plate XXII but are listed in the text in order.

The second advantage is that no primary distinction between various die combinations is made due to metals, unless it is desired. Our suggestion would be that when a piece is described, that the metal only be cited in its description when it is other than copper, which 99% of the time was the intended metal.

A discussion of Civil War tokens struck in various metals might be helpful. Unfortunately, for the catalogers of this series, while perhaps it is fortunate for collectors, the early collectors of Civil War tokens during and immediately succeeding the War, wanted rare varieties for their collections. Since the pieces were not of an official nature in the first place, various collectors caused to be made many varieties of these tokens in metals other than copper;

viz., brass, nickel, German silver, copper-nickel, white metal, silver, and lead. However, many of these off-metal variations had to have been struck previous to the striking of the regular copper issues for general circulation as can be shown by die breaks. Thus, it is difficult at best to decide which of the off-metals belong with the series, and which do not. Thus, one is left with the alternative of not listing any off-metals or listing them all. Naturally, the decision must be made to list them all, but by referring to the die combinations as the key to the coin, rather than to separate numbers for each die combination **and** each metal thereof, some of the stigma can be removed. Thus, although there are over 1500 different Patriotic pieces in all, there are perhaps only 600 or 700 different die combinations.

In virtually all cases, the off-metal variations of the Patriotic series are extremely rare, only a limited number having been struck. In almost all cases, this was less than 20 full sets, and often many less. It should be pointed out that although most Patriotic tokens regularly occur in copper, many of the Tradesmen's Cards regularly were struck in brass (for instance, the Boutwell cards of Troy, New York) or lead (for instance the Hastings' cards of New York). Also in many cases the tokens are struck over other coins. This may be other Civil War tokens, or in some cases over copper-nickel cents dated from 1857 to 1863 (regular Government issues—there is even a report of an overstrike on an 1856 Flying Eagle cent) or over U.S. dimes generally dated in the 1850's. These overstrikes are recognizable by the original impression showing thru the overstrike, and in the case of the dimes, the piece has a reeded

edge. The overstrikes on cents and dimes are actively sought after by collectors.

The metals in which Civil War cents are struck and the abbreviations used are as follows:

C—Copper (1)
BR—Brass
N—Nickel (2)
C-N—Copper-nickel
WM—White metal
GS—German silver
S—Silver
L—Lead (3)
Z—Zinc
S pl.—Silver plated

The amateur collector often has great difficulty distinguishing between the various metals. The best solution to this problem is to consult a reputable dealer. However, the following may be of some help. Copper pieces generally look like worn Lincoln or Indian Head cents. Brass pieces have a distinct yellow color resembling a tarnished, dirty doorknob. The nickel pieces resemble in shade the wartime "silver" Jefferson nickel when uncirculated. German silver often has the shade of circulated "silver" Jefferson nickels. Copper-nickel has an entirely different specific gravity than copper and closely resembles the copper-nickel cents of 1857 to 1864. White metal is a soft composition metal that is very light in color and might be said to resemble light

colored chrome plating. In addition a white metal piece, when placed on the fingertip, and struck by a copper coin will **not** give a sharp, lasting "ping." The lead and white metal pieces will not ring—all other metals do! Lead resembles white metal, but is quite dense and is invariably much darker (some lead pieces are found copper-plated). In all cases, the so-called zinc pieces (which invariably occur with two different Indian Head obverses— one being die 75) are copper pieces that are zinc washed. This is an original washing and was not done after the war!

This leads into the subject of silver. In short, we would recommend the inexperienced collector to BEWARE of any tokens which purport to be silver. Many, many of the copper pieces have been silver plated over the years. Silver pieces almost never turn up except in large collections. Original silver pieces are in no case at all common. The plated pieces can be very deceptive—they will tarnish very nicely. The best test is to take the specific gravity of the piece. Another test, though more qualitative in nature is as follows. Take a copper token, preferably of the same variety. The copper piece, when tapped by another coin on the finger tip will give a lower pitched, much longer lasting tone than the silver piece. If the "silver" and copper piece of the same type have almost identical rings, **beware**. This is not fool-proof, but works most times. Another common test used, though we frown on it, is to scratch the edge of the coin with a sharp knife. If the copper shows through, the piece is plated, although you risk the chance of defacing a potentially valuable coin. Of course in the case of silver pieces **over** dimes, they can always be identified

(1) There is no distinction, except in a few isolated cases between the various kinds of copper used in these pieces, although a few pieces are listed as bronze, which has a deeper color than copper, similar to uncirculated Indian Head cents.

(2) It is very difficult to distinguish Nickel from German Silver, although both metals were used. In general, the simple way of telling them apart is that nickel will not tarnish, while German Silver does.

(3) Lead includes many of the New York pieces that were struck in a dark composition metal, but there is usually little trouble in distinguishing them.

by the reeded edge. We have never seen a Civil War cent in gold, though one has been reported. Only a very few tokens were originally issued either with silver plating or gold plating (such as 128/289 and 128/290). Almost all other pieces are not contemporary—as such we have not priced these pieces above $1.50 apiece in the ensuing list.

The rarity of these Civil War coins, is at best a guess based on our experience. We have examined numerous collections as well as having inventories on many more and have probably examined at one time or another 100,000 Civil War cents. The rarity scale used is slightly different than the one proposed by Dr. W. H. Sheldon in "Penny Whimsy," but we have found this modification useful in this case. The rarity from R-1 (very common) to R-10 (unique—only **one** known) is based on the number known as follows:

Rarity Scale	Estimated number in existence
R-1	Greater than 5000 (very common)
R-2	Between 2000 and 5000
R-3	Between 500 and 2000
R-4	Between 200 and 500
R-5	Between 75 and 200
R-6	Between 20 and 75
R-7	Between 10 and 20
R-8	Between 5 and 10
R-9	Between 2 and 4
R-10	Unique (1 only)

This rarity scale is based on the assumption that about 1,000,000 Civil War tokens are still existent, and even if this is not a good guess, the ratings will still have the same relative meaning. This is especially true for rarities over R-7 which are based on actual surveys of the largest collections and include most of the off-metals known.

An attempt has been made to price the tokens, based on their rarity and on the metal in which they are struck. This list, shown in Table I, is a tentative one, and of course cannot take into account in-

TABLE I

Valuations of Civil War Tokens Based on Rarity and Metal

Rarity	Copper	Brass	Nickel and German Silver	Copper-Nickel	Copper-Nickel over C-N Cent	White Metal	Silver	Silver over US. Dime	Silver plated	Gold plated	Zinc	Lead
R-1	$ 1.35	$ 1.35	$ —	$ —	$ —	$ —	$ —	$ —	$ —	$ —	$ —	$ 2.00
R-2	1.65	1.65	5.00	—	—	—	—	—	—	—	—	3.00
R-3	1.80	1.80	6.00	5.00	—	—	—	—	—	—	—	4.00
R-4	2.00	2.00	7.00	6.00	18.00	7.50	10.00	—	—	—	6.00	6.00
R-5	2.50	2.50	8.00	8.00	22.50	9.00	13.00	—	2.00	2.00	7.50	7.50
R-6	3.25	3.25	10.00	11.00	30.00	11.00	18.00	—	3.00	—	10.00	10.00
R-7	4.50	4.50	12.50	14.00	37.50	13.00	25.00	65.00	5.00	5.00	13.50	13.50
R-8	9.00	10.00	16.00	17.50	50.00	17.00	40.00	85.00	10.00	10.00	16.00	16.00
R-9	17.50	17.50	27.50	30.00	75.00	27.50	60.00	100.00	25.00	25.00	22.50	22.50
R-10	When sold, values are speculative.											

dividual variations of demand. Thus, although the famous SPOOT error Dix token (209/414) is given a R-2 based on the number seen, it would probably command twice its suggested price or more because of its popularity. This table of prices, which is all inclusive for this series, is based upon coins in fine to very fine condition for the copper pieces. In the case of uncirculated copper coins about twice the listed price is suggested, while good pieces are suggested as half the listed price. In the case of the off-metal pieces, they almost invariably occur uncirculated, and thus **no distinction as to price should be made in this case.**

This suggested price scale is tentative, but we believe it is realistic based on today's market. However, the market is rising and this table will have to be revised yearly. At least, we hope this price schedule will discourage practices of advertising extremely common pieces at fabulously high prices (such as 189/399, a rarity R-1 copper piece, being offered by a dealer recently in a national magazine at the absurb sum of $65.00).

In the remarks column, reference is occasionally made to various other references in addition to Hetrich and Guttag. These are as follows, with the abbreviation used:

Abbrev. **Reference**
B Baker, W. S. "Metallic Portraits of Washington," Philadelphia, 1885
DeW DeWitt, J. D. "A Century of Campaign Buttons 1789-1889," Hartford, Conn., 1959
F.FR. Fuld, M. and G. "Medallic Memorials to Franklin," **The Numismatist 69:1393** Dec., 1956
F.LA Fuld, M. and G. "Medallic Memorials to Lafayette," **The Numismatist 70:1027** September, 1957

F Fuld, M. and G. "The Wealth of the South Mulings," **The Numismatic Scrapbook Magazine** 1785 Sept., 1958
K King, R. P. "Lincoln in Numismatics" **The Numismatist 37:55** February, 1924
Kurth Kurth, H. "American Game Counters" **The Numismatic Scrapbook Magazine,** December, 1952
M Marvin, W. T. R. "The Medals of the Masonic Fraternity" Boston, 1880
W Wismer, D. C. "The Varieties of the Year Dix Tokens of the Year 1863," Hatboro, Pa. Privately printed, 1922.

We feel that several other comments as to the inclusion of some of the pieces in the series is warranted. At the end of the list are grouped a series of pieces (Dies 481 to 493) that so closely resemble the Rhode Island muling series, that it was decided to include them. Likewise, the Wealth of the South Mules are so closely related to this series (Dies 506 to 519) that it was decided to include them, although the strictly political pieces were omitted. Naturally, the reverses bearing merchant's names were not included in this part of the book.

The extensive series of mulings of Rhode Island, since all the dies were combined in all combinations, lead to some varieties that have to be called patriotic in nature as no where do they have an advertising allusion on them (Dies 134, 146, 184, 283, 386, 427, 472, and 480A). Most combinations have been found. Many of these were originally listed under store cards by Hetrich and Guttag.

A number of miscellaneous pieces, called Civil War cents, by Barnet as well as some possible fantasies are included, such as the 494 through 505. However, Civil

War "dog tags" have been omitted. In addition, a number of advertising pieces, of a completely non-local nature are included, such as dies 462, 467 through 471, and 473 through 476. Since these are non-local pieces, they are put under the patriotic series.

A number of pieces listed are called incuses, which makes some new (and almost always rare) varieties. These so-called incuse pieces (sometimes called brockages) arise from a coin sticking in the press, and the next planchet being inserted and the dies struck. The obverse of the already struck coin becomes the reverse of the new coin (but in reverse relief and a mirror image) and the regular obverse die shows. Such pieces are met with in the Civil War cents as well as in regular coinage.

A few dies are not listed, which have been reported to exist, since all attempts to locate them have failed. Although they may exist, often the references to such pieces are due to faulty descriptions. H and G's die 127 has not been found, but the combination like it was found at the ANS using die 126— thus it is felt that 127 does not exist. The following varieties have been mentioned, but have not been located: die similar to 34 but letters closer together; die similar to 47 but end of bust turned up; and a die die similar to 90. Undoubtedly, new dies will be discovered but probably 99% of them are now known.

At the end of this book will be found an index to similar die varieties in a tabular form giving distinctive characteristics between similar dies. Thus a distinction between the various flag varieties or the various Indian heads can be made so that the plates will be easier to use. Likewise a cross index

of the old H and G die numbers and the numbers is given in Table II.

Also, a list of the dies manufactured by the same firm, and its name and location, is given in the Appendix. This table is one result of a game we have christened "Civil War mumbly-peg." By listing all the obverse and reverse dies that are used together, as well as comparing to the store card issues, it soon becomes apparent that dies were either traded among manufacturers, or that several firms used the talents of a number of engravers in different cities (the same engravers working for perhaps two different firms). Thus, it is relatively easy to list some of the manufacturers and engravers of these tokens, such as E. Sigel, L. Roloff, C. D. Horter, A. W. Escherich, Mossin and Marr, H. and W. Johnston, S. D. Childs, Key, Scovill Manufacturing Co., J. A. Hughes, J. Stanton, J. S. Murdock and Spencer, W. H. Bridgens, and W. K. Lanphear. However, for instance it is apparent that a Marr piece from Milwaukee was struck from an Escherich die from Chicago and that many of the Sigel dies are used with both the Roloff and Horter dies. There is also the strange appearance of a set of hubs (not the actual dies) first having been used in Indiana and later in Waterbury, Conn. This study can be a fascinating pastime, but a complete solution to this "mumbly-peg" problem will probably never be achieved. The list given in the Appendix is correct to the best of our knowledge.

Comments as to the manner in which to collect Civil War tokens might be helpful. We can suggest many ways to do this, in addition to trying to obtain one of each specimen (a literally hopeless task, even of pieces not in museums). Many people collect one of each die

that is used or one of each state. Some people try to collect one from each town in that state. Others try to collect one from each merchant that issued tokens, while other collectors specialize in either the Patriotic series or one particular state. The Civil War series is a fascinating one—there are many ways to enjoy this type of collection and it is our hope that our fellow collectors will find this series more understandable after perusing this book.

Errata

Die 150 shown on Plate VI is the same as die 149. Cut has been deleted. Use photo of die 150 shown on Plate XXII.

Die 329 is the same as die 324. Cut of 329 has been deleted.

Addenda

The following dies were discovered during publication and are denoted by subletters, placing them near their natural order. The following list gives the Plates where they appear.

In Mr. DeWitt's book on Campaign Buttons, he pointed out two additional dies, combined with Lincoln obverses, originally listed by Robert P. King. Unfortunately photographs of these pieces are not available. Their description is as follows:

Die 137A Jackson in a plain field facing left.

Die 406A 'Proclaim Liberty Throughout the Land. Lincoln.'

Since dies 6, 6A, 6B, 7, 7A, 7B and 8 are all extremely similar, enlargements of each are shown on Plates XX and XXI.

Acknowledgments

So many people have contributed to this listing that it is impossible to list them all. Many have passed on such as Dr. Hetrich, D. C. Wismer, Waldo Moore, Joseph Barnett, Otto Kersteiner and we have been fortunate to obtain the benefit of their original notes on this series. Also much use has been made from the collection of Civil War tokens at the American Numismatic Society. Many collectors have brought new pieces to our attention, especially those who are specialists in particular fields, such as Clifton Temple, Eric Newman, Arthur Fritz, the late Raymond Haggenjos, William Jacka, W. J. Fayeweather, Robt. Hailey, and many others. We are also indebted to Archer Graham, T. V. Buttrey, Jr., Harry Abuhove, Maurice Gould, Matt Rothert, Elmer G. Nelson, George Cormier, M. Jacobowitz, H. M. Mareska and Max M.

Schwartz for assistance. The late Charles W. Foster kindly lent us coins from his fine collection so that many new varieties could be added. Our good friend, Lionel Rudduck, kindly supplied us with data on many new, unlisted varieties contained in his fine collection. In addition, his thorough proof-reading eliminated many confusing errors.

We are indebted to Kenneth Bressett who painstakingly took (and retook) the photographs that accompany the article. We are especially grateful to Wayne S. Rich and Martin Jacobowitz for their continuing help in setting rarities, prices, and the thankless job of proofreading.

Correspondence concerning additions or corrections welcomed. Write the authors at P.O. Box 6047, Baltimore 31, Maryland.

Obv.	Rev.	Metal	Rarity	H-G No.
1	105	C	R-9	
	(B439)			
1	105	BR	R-8	
1	105	WM	R-9	
1	198	C	R-7	1
1	198	BR	R-7	2
1	198	N	R-8	
1	198	WM	R-8	
1	229	C	R-1	7
1	229	BR	R-3	8
1	229	N	R-7	9
1	229	C-N	R-7	10
1	229	WM	R-7	11
1	229	S	R-8	12
1	359	C	R-7	
1	359	BR	R-8	
1	359	N	R-7	
1	359	C-N	R-9	
1	359	WM	R-8	
1	360	C	R-7	14
1	360	BR	R-7	15
1	360	N	R-7	16
1	360	C-N	R-9	
1	360	WM	R-7	18
1	391	C	R-1	20
1	391	BR	R-4	21
1	391	N	R-7	22
1	391	C-N	R-7	23
1	391	WM	R-7	24

Obv.	Rev.	Metal	Rarity	H-G No.
1	391	L	R-8	25
1	391	S	R-8	26
1	436	C	R-3	28
1	436	BR	R-7	29
1	436	N	R-8	30
1	436	C-N	R-7	31
1	436	WM	R-7	32
1	436	S	R-8	33
1	Blank	C-N	R-9	
	(Over C-N cent)			
2	270	C	R-8	
3	Blank	BR	R-9	
3	273	BR	R-6	35
3	464	BR	R-9	
3	465	BR	R-9	
3	465A	BR	R-9	
4	354	L	R-7	37
5	288	C	R-2	39
5	288	BR	R-3	40
5	288	N	R-8	41
5	288	L	R-9	
5	288	Gold Plate	R-7	
6	268	C	R-1	45
6A	269	C	R-4	47
6A	317	C	R-1	
6B	6B Incuse	C	R-9	
	(Obverse incused)			
6B	308	C	R-3	49
6B	309	C	R-1	51
6B	310	C	R-3	53
6C	314	C	R-5	
	(1 of 1863 reads I)			
7	7 Incuse	C	R-8	
	(Obverse incused)			
7	313	C	R-2	
7	315	C	R-2	59
7A	7A Incuse	C	R-9	
	(Obverse incused)			
7A	316	C	R-3	61
7A	317	C	R-1	63
7B	315	C	R-5	
8	8 Incuse	C	R-9	43
	(Obverse incused)			
8	268	C	R-5	
8	309	C	R-3	
8	313	C	R-2	55
8	314	C	R-1	57
9	85	C	R-9	
9	211	C	R-8	65

Obv.	Rev.	Metal	Rarity	H-G No.	Obv.	Rev.	Metal	Rarity	H-G No.
9	238	C	R-8		20	384	BR	R-8	111
9	298A	C	R-9		21	170	C	R-10	
9	400	C	R-8		21	170	WM	R-10	
9	404	C	R-9		22	22 Incused	C	R-9	
9	405	C	R-6	74		(Obverse incused)			
9	405	BR	R-8	75	22	418	C	R-3	117
9	406	C	R-5	77	22	418	BR	R-8	
9	407	C	R-7	79	22	442	C	R-2	119
9	431	C	R-7		22	442	BR	R-8	120
10	298	C	R-2	67	23	271	C	R-3	122
10	298	BR	R-8	70	23	271	BR	R-9	
10	298	L	R-9		23	271	N	R-8	124
10	312	C	R-1	72	23	271	C-N	R-9	125
11	298	C	R-1	68	23	306	C	R-1	128
11	312	C	R-3		23	306	BR	R-4	129
12	12 Incused	C	R-9		23	306	N	R-8	130
12	297	C	R-2	81	23	306	C-N	R-9	
12	297	C-N	R-10		23	306	WM	R-9	132
12	297	L	R-8		24	246	C	R-2	134
12	351	C	R-9		24	246	BR	R-5	135
13	297	C	R-2	113	25	262	C-N	R-10	141
13	297	BR	R-8			(Obverse struck over C-N cent)			
13	297	L	R-9		25	418	C	R-4	143
14	297	C	R-3	115	25	418	BR	R-6	
14	297	BR	R-8		26	Blank	C	R-10	137
14	297	L	R-9		26	26 Incused	C	R-9	139
15	319	C	R-2	83		(Obverse incused)			
15	319	BR	R-7	84	26	418	C	R-2	
15	319	N	R-7	85	26	418	BR	R-6	
15	319	C-N	R-7	86	26	418	N	R-8	145
15	319	WM	R-7	87	26	418	L	R-9	
15	319	GS	R-8		27	27 Incused	C	R-9	
15	319	S	R-8			(Obverse incused)			
	(Over U.S. dime)				27	365	C	R-3	151
16	300	C	R-3	90	28	303	C	R-2	153
16	301	C	R-4		28	303	BR	R-5	154
16	353	C	R-7	92	29	303	C	R-2	156
17	388	C	R-2	94	29	303	BR	R-5	157
18	300	C	R-2	96	30	280	N	R-10	1305
18	302	C	R-5		31	279	C	R-7	147
18	304	C	R-7		31	447A	C	R-9	
18	305	C	R-9		31A	275	C	R-7	1255
18	337	C	R-6	98	32	275	C	R-7	149
18	353	C	R-3	100	33	275	C	R-7	159
19	396	C	R-2	102	34	275	C	R-6	161
19	396	BR	R-4	103	34	275	BR	R-8	
20	303	C	R-3	105	34	276	C	R-8	
20	303	BR	R-4	106	34	277	C	R-5	163
20	318	C	R-8	108	34	278	C	R-5	165
20	384	C	R-7	110	35	265	C	R-5	167

Obv.	Rev.	Metal	Rarity	H-G No.	Obv.	Rev.	Metal	Rarity	H-G No.
35	274	C	R-6	169	45	332	S pl.	R-5	
35	277	C	R-5	171	46	46 Incused	C	R-9	
35	278	C	R-8	173		(Obverse incused)			
36	36 Incused	C	R-9		46	335	C	R-2	221
	(Obverse incused)				46	335	BR	R-8	222
36	271	C	R-3	175	46	335	N	R-8	223
36	271	N	R-9		46	335	C-N	R-8	224
36	340	C	R-2	177	46	335	WM	R-7	225
36	340	BR	R-5	178	46	335	GS	R-8	
36	340	S	R-9	181	46	335	S	R-7	226
36	432	C	R-4	183	46	339	C	R-1	228
37	37 Incused	C	R-9	185	46	339	BR	R-7	229
	(Obverse incused)				46	339	N	R-8	230
37	255	C	R-3	187	46	339	C-N	R-8	231
37	256	C	R-2	189	46	339	WM	R-8	232
37	434	C	R-1	191	46	339	GS	R-8	
37	434	BR	R-4	192	46	339	S	R-7	233
37	434	N	R-8	193	47	332	C	R-1	235
37	434	C-N	R-9	194	47	332	BR	R-7	236
37	434	WM	R-8	195	47	332	N	R-9	
37	434	S	R-8	196	47	332	C-N	R-8	238
38	Blank	C	R-10		47	332	WM	R-7	239
38	438	C	R-9	198	47	332	S	R-8	240
38	438	C-N	R-9		48	48 Incused	C	R-10	242
39	448	C	R-9			(Obverse incused)			
40	Blank	C	R-10		48	299	C	R-1	244
40	193	C	R-9		48	299	S pl.	R-5	
40	193	BR	R-9			(Plated)			
41	178	WM	R-9		49	343	C	R-1	246
41	240	C	R-8		49	343	BR	R-6	
41	267	WM	R-8		49	343	C-N	R-9	248
41	337	C	R-2	200	50	335	C	R-1	250
41	341	C	R-9		50	342	C	R-3	252
41	342	C	R-9		50	342	BR	R-8	253
42	Blank	C	R-10		50	342	N	R-8	254
42	42	C	R-9		50	342	C-N	R-8	255
42	42 Incused	C	R-9		50	342	WM	R-8	256
	(Obverse incused)				50	342	GS	R-8	
42	336	C	R-3	202	50	342	S	R-9	
42	336	BR	R-4	203	51	333	C	R-6	
42	336	C-N	R-8	205	51	334	C	R-1	258
42	336	WM	R-8	206	51	334	BR	R-8	259
42	336	S	R-8	207	51	334	N	R-7	260
43	387	C	R-4	209	51	334	C-N	R-7	261
43	387	L	R-9		51	334	WM	R-7	262
43	388	C	R-2	211	51	334	GS	R-8	
43	388	S	R-9		51	334	S	R-9	
44	350	C	R-2	213	51	334	S	R-9	
45	332	C	R-1	215		(Over U.S. dime)			
45	332	C-N	R-7	218	51	342	C	R-1	264

Obv.	Rev.	Metal	Rarity	H-G No.	Obv.	Rev.	Metal	Rarity	H-G No.
51	342	BR	R-7	265	54	343	C	R-4	305
51	342	N	R-7	266	54	344	C	R-3	
51	342	C-N	R-7	267	55	162	C	R-1	307
51	342	C-N	R-9		56	161	C	R-3	309
	(Over C-N cent)				56	161	BR	R-7	310
51	342	WM	R-7	268	56	161	N	R-7	311
51	342	GS	R-8		56	161	C-N	R-8	
51	342	S	R-9		56	161	C-N	R-7	312
51	342	S	R-8	269		(Over C-N cent)			
	(Over U.S. dime)				56	161	WM	R-7	313
51	342A	C	R-5		56	161	L	R-9	
52	296	C	R-4	271	56	161	GS	R-8	
52	296	BR	R-8	272	56	161	S	R-8	
52	296	N	R-8	273	56	162	C	R-8	
52	296	C-N	R-8	274	56	229	C	R-6	315
52	296	WM	R-8	275	56	229	BR	R-7	316
52	296	GS	R-8		56	229	N	R-7	317
52	296	S	R-9		56	229	C-N	R-7	318
52	335	C	R-3	277		(Over C-N cent)			
52	335	BR	R-7	278	56	229	WM	R-7	319
52	335	N	R-8	279	56	229	GS	R-8	
52	335	C-N	R-7	280	56	229	S	R-8	
52	335	WM	R-7	281	56	229	S	R-9	320
52	335	GS	R-8			(Over U.S. dime)			
52	335	S	R-9		56	436	C	R-6	322
52	342	C	R-1	283	56	436	BR	R-7	323
52	430	C	R-3	285	56	436	N	R-7	324
52	430	BR	R-8	286	56	436	C-N	R-8	
52	430	N	R-8	287	56	436	C-N	R-7	325
52	430	C-N	R-9			(Over C-N cent)			
52	430	C-N	R-8	288	56	436	WM	R-7	326
	(Over C-N cent)				56	436	GS	R-8	
52	430	WM	R-7	289	56	436	S	R-8	
52	430	GS	R-8		56	436	S	R-9	327
52	430	S	R-9	290		(Over U.S. dime)			
	(Over U.S. dime)				57	57 Incused	C	R-10	
53	53 Incused	C	R-9			(Obverse incused)			
53	336	C	R-1	292	57	185	C	R-8	
53	336	BR	R-7	293	57	467	C	R-7	
53	336	N	R-7	294	57	473	C	R-7	
53	336	C-N	R-7	295	57A	444	N	R-9	
	(Over C-N cent)				57A	473	C	R-9	6888
53	336	WM	R-7	296	57A	473	L	R-9	
53	336	GS	R-8		58	58 Incused	C	R-8	
53	336	S	R-8			(Obverse incused)			
53	336	S	R-9	297	58	439	C	R-3	329
	(Over U.S. dime)				58	439	WM	R-9	
54	179	C	R-2	299	59	385	C	R-2	331
54	335	C	R-5	301	59	385	BR	R-4	332
54	342	C	R-5	303	59	453	C	R-7	

Obv.	Rev.	Metal	Rarity	H-G No.
59	453	BR	R-5	
60	Blank	WM	R-10	
60	200	C	R-8	334
60	200	WM	R-8	338
60	346	C	R-4	340
60	346	C	R-4	
(Overstruck)				
60	346	N	R-8	342
60	346	C-N	R-7	343
(Over C-N cent)				
60	346	WM	R-9	344
61	105	C	R-7	346
(B494)				
61	105	C-N	R-9	349
(Over C-N cent)				
61	198	C	R-3	352
61	355	C	R-2	354
61	355	C-N	R-9	357
(Over C-N cent)				
61	355	S pl.	R-5	
62	367	C	R-3	362
62	367	C	R-9	
(On very large flan)				
62A	367	C	R-5	
(No ES under neck)				
62A	367	C-N	R-8	
(No ES under neck)				
62A	369	C-N	R-9	
(No ES under neck)				
(Over C-N cent)				
63	63 Incused	C	R-9	
(Obverse incused)				
63	366	C	R-1	364
63	366	N	R-9	366
63	443	C	R-2	369
63	443	C-N	R-8	
64	362	C	R-4	371
64	362	C-N	R-9	
65	371	C	R-4	
65A	371	C	R-7	
66	370	C	R-2	373
66	370	BR	R-8	
67	67 Incused	C	R-9	
(Obverse incused)				
67	Blank	C	R-10	
67	372	BR	R-7	376
67	372	N	R-7	377
67	372	C-N	R-5	
67	372	C-N	R-7	378
(Over C-N cent)				

Obv.	Rev.	Metal	Rarity	H-G No.
67	372	WM	R-8	379
67	372	GS	R-8	
67	372	S	R-8	
68	105	C	R-9	
68	105	BR	R-9	
68	105	WM	R-9	
68	105	S	R-9	
68	119	C	R-9	
(B495)				
68	198	C	R-4	381
68	198	WM	R-9	385
68	198	S	R-9	
68	199	C	R-8	387
68	199	BR	R-8	388
68	199	N	R-9	389
68	199	WM	R-9	
68	199	GS	R-9	
68	355	C	R-4	393
68	359	C	R-8	395
68	359	BR	R-8	396
68	359	N	R-8	397
68	359	WM	R-8	
68	359	C-N	R-9	
68	360	C	R-8	401
68	360	BR	R-9	402
68	360	N	R-9	403
68	360	WM	R-9	
68A	369	C	R-3	407
68A	369	C-N	R-8	
69	261	C-N	R-9	
69	367	C-N	R-9	
69	367	C-N	R-10	
(Over C-N cent)				
69	369	C	R-3	409
69	369	C	R-8	
(On very large flan)				
69	369	C-N	R-8	412
(Over C-N cent)				
69	369	C-N	R-9	
69	369	S'd	R-5	
70	281	C	R-4	415
70	444	C	R-9	417
70	452	C	R-9	
70	456	C	R-9	
71	71 Incuse	C	R-9	
(Obverse incused)				
71	148	Z	R-9	
71	182	Z	R-10	
71	183	C	R-9	
71	183	Z	R-9	

Obv.	Rev.	Metal	Rarity	H-G No.
71	281	C	R-9	419
71	444	C	R-9	421
71	452	BR	R-9	
71	452	Z	R-9	
71	455	BR	R-9	
71	456	Z	R-9	
71	473	BR	R-9	
72	Blank	C	R-10	
73	74	C	R-5	425
73	84	C	R-4	423
73	84	C	R-9	
	(Reeded edge)			
74	84	C	R-9	
	(Reeded edge)			
75	459	C	R-8	
	(Reeded edge)			
75	459	BR	R-9	
	(Reeded edge)			
75	467	C	R-8	
	(Reeded edge)			
75	467	BR	R-8	
	(Reeded edge)			
76	456A	C	R-9	
	(Reeded edge)			
76	456B	BR	R-9	
	(Reeded edge)			
76	470	C	R-7	
	(Reeded edge)			
76	473	C	R-9	6890
	(Reeded edge)			
77	331	C	R-4	427
78	330	C	R-3	429
79	297	C	R-9	431
79	351	C	R-1	433
79	351	BR	R-10	
79	351	S pl.	R-5	
80	351	C	R-3	435
80	351	BR	R-8	436
80	351	C-N	R-10	
81	351	C	R-1	438
81	351	BR	R-8	439
82	82 Incused	C	R-8	441
	(Obverse incused)			
82	351	C	R-1	443
82	351	BR	R-8	444
82	351	C-N	R-9	
82	352	C	R-1	446
83	264	C	R-4	448
83	264	BR	R-9	449
84	148	C	R-8	453

Obv.	Rev.	Metal	Rarity	H-G No.
84	444	C	R-8	451
84	444	BR	R-9	
85	431	C	R-8	455
86	357	C	R-2	457
86	357	BR	R-9	458
86	357	N	R-9	459
87	356	C	R-2	462
87	356	BR	R-7	463
87	356	BR	R-9	
	(Reeded edge)			
88	361	C	R-3	465
88	361	BR	R-8	
88	361	C-N	R-9	
88	361	C-N	R-9	
	(Over C-N cent)			
88	361	S	R-9	
89	356	C	R-2	467
89	356	BR	R-7	
90	364	C	R-1	469
90	364	BR	R-8	
90	364	L	R-9	472
91	303	C	R-3	474
91	303	BR	R-8	
91	373	C	R-7	476
91	432	C	R-9	478
91	432	BR	R-8	479
91	432	N	R-8	480
91	432	C-N	R-9	
91	432	C-N	R-9	481
	(Over C-N cent)			
91	432	WM	R-8	482
91	432	GS	R-8	
91	432	S	R-9	483
91	435	C	R-8	485
91	435	BR	R-8	
91	435	N	R-8	
91	435	C-N	R-8	
91	435	WM	R-8	489
91	435	L	R-9	
91	435	GS	R-9	
91	435	S	R-9	490
92	105	N	R-9	
92	105	WM	R-9	
92	119	C	R-9	
92	119	BR	R-9	493
92	119	N	R-9	
92	119	C-N	R-10	
92	119	WM	R-9	496
92	198	BR	R-9	499
92	198	N	R-9	500

Obv.	Rev.	Metal	Rarity	H-G No.
92	198	C-N	R-10	
92	198	WM	R-9	502
92	199	C	R-3	504
92	199	BR	R-8	505
92	199	N	R-9	
92	199	C-N	R-9	507
(Over C-N cent)				
92	199	WM	R-8	508
92	199	L	R-10	
92	199	S pl.	R-5	
(Plated)				
92	199	S	R-8	509
(Over U.S. dime)				
92	440	C	R-9	
92	440	WM	R-8	514
93	93 Incused	C	R-9	
(Obverse incused)				
93	362	C	R-2	516
93	394	C	R-3	518
93	394	S pl.	R-5	
(Plated)				
94	363	C	R-3	520
95	(Blank)	C	R-9	
95	95 Incused	C	R-9	522
(Obverse incused)				
95	368	C	R-2	524
95	368	C-N	R-8	527
(Over C-N cent)				
95	368	L	R-9	
96	116	C	R-8	530
96	116	BR	R-8	531
96	116	WM	R-8	534
96	129	C	R-9	
(K119, DeW. AL 1864-76)				
96	129	BR	R-9	527
96	129	WM	R-9	
96	129	S	R-9	
96	129	G pl.	R-9	
96	144	C	R-9	
96	144	BR	R-9	543
96	144	WM	R-9	546
96	284	BR	R-8	548
96A	131A	C	R-8	
(K104, DeW. AL 1864-38)				
96A	131A	BR	R-8	
96A	131A	WM	R-8	
97	389	C	R-2	550
(F.LA. 1863.1)				
97	389	C	R-9	549
(Very large flan, 23 mm.)				

Obv.	Rev.	Metal	Rarity	H-G No.
97	389	BR	R-7	551
97	389	C-N	R-6	
97	389	C-N	R-8	553
(Over C-N cent)				
97	389	WM	R-9	554
97	389	S	R-8	555
(Over U.S. dime)				
98	291	C	R-4	557
99	292	C	R-3	
99	292	BR	R-8	
100	341	C	R-8	559
101	263	C	R-9	561
102	Blank	C	R-9	
103	293	C	R-5	563
103	375	C	R-4	565
104	263	C	R-5	567
104	521	C	R-9	
(Kurth 83B)				
105	196	C	R-8	
(B496)				
105	198	BR	R-8	
(B496A)				
105	198	N	R-9	570
105	198	C-N	R-9	
105	198	WM	R-9	572
105	199	C	R-9	
(B498)				
105	199	BR	R-9	
105	199	N	R-9	576
105	199	C-N	R-9	
105	199	WM	R-8	578
105	199	S	R-9	
105	229	C	R-9	
(B488)				
105	229	BR	R-9	
105	355	C	R-3	580
105	355	C-N	R-9	
105	358	C	R-4	582
105	359	C	R-8	
105	359	WM	R-9	588
105	360	C	R-9	
(B471)				
105	360	BR	R-9	
105	360	N	R-9	
105	360	C-N	R-9	
105	360	WM	R-8	594
105	360	L	R-9	
105	391	C	R-9	
105	391	BR	R-9	
105	391	N	R-9	

Obv.	Rev.	Metal	Rarity	H-G No.
105	391	C-N	R-9	
105	391	WM	R-9	
105	436	C	R-9	
105	436	N	R-9	
105	436	WM	R-9	
106	Blank	C	R-10	
106	432	C	R-4	596
(B491)				
106	432	BR	R-8	597
106	432	N	R-8	598
106	432	C-N	R-8	
106	432	C-N	R-8	599
(Over C-N cent)				
106	432	C-N	R-4	
(Over Brimelow card)				
106	432	WM	R-9	
106	432	S	R-8	601
107	107 Incuse	C	R-8	603
107	108	C	R-7	604
107	108	N	R-8	606
107	108	C-N	R-8	607
(Over C-N cent)				
107	271	BR	R-9	617
107	432	C	R-1	619
(B490)				
107	432	BR	R-5	620
107	432	N	R-8	621
107	432	C-N	R-8	622
107	432	WM	R-9	623
107	432	GS	R-9	
107	432	S pl.	R-5	
(Plated)				
108	201	C	R-3	610
(B486)				
108	201	BR	R-4	611
108	201	N	R-9	
108	201	C-N	R-9	
108	201	WM	R-8	614
108	201	S	R-8	615
109	442	C	R-5	625
(B474)				
110	110 Incused	C	R-9	
110	271	C	R-9	
110	442	C	R-1	627
111	271	C	R-4	629
(B480)				
111	271	N	R-9	
111	340	C	R-3	631
(B501)				
111	340	N	R-9	633

Obv.	Rev.	Metal	Rarity	H-G No.
112	396	C	R-1	635
(B587)				
112	396	S'd	R-5	
113	127	C	R-9	
(K220, B244, DeW. AL 1864-41)				
113	294	C	R-9	637
(B484)				
113	432	C	R-9	639
(B492)				
114	432	C	R-9	
114	432	S	R-9	
115	Blank	S	R-10	
115	466	L	R-9	
116	129	C	R-9	
(K116, B241, DeW. AL 1864-74C)				
116	129	WM	R-8	
116	129	S	R-9	
116	144	C	R-9	
(B254)				
116	144	BR	R-9	
116	144	WM	R-9	
116	153	C	R-8	
(B207, F.FR. T.NL.3)				
116	153	BR	R-8	
116	153	N	R-9	
116	153	WM	R-9	
116	282	C	R-9	641
(B502)				
116	282	WM	R-9	
116	477	WM	R-9	
(B637)				
117	420	C	R-1	643
(B473)				
117	420	BR	R-4	644
117	420	N	R-9	645
117	420	C-N	R-9	
117	420	WM	R-8	647
117	420	S	R-8	648
(Over U.S. dime)				
117	420	L	R-9	
118	418	C	R-2	650
B485)				
118	418	BR	R-5	651
118	419	C	R-4	
(B485A)				
119	Blank	WM	R-10	653
119	199	C	R-9	
(B499)				
119	199	BR	R-9	
119	199	N	R-9	
119	199	C-N	R-9	

Obv.	Rev.	Metal	Rarity	H-G No.
119	199	WM	R-9	655
119	360	C	R-9	
	(B472)			
119	360	BR	R-8	657
119	360	N	R-8	
119	360	C-N	R-9	
119	360	WM	R-8	
119	398	C	R-1	659
	(B500)			
119	398	BR	R-8	
120	120 Incused	C	R-9	
	(Obverse incused)			
120	255	C	R-9	661
	(B465)			
120	255	BR	R-7	662
120	255	C-N	R-9	
120	255	WM	R-9	665
120	255	S	R-9	
	(Over U.S. dime)			
120	255	S	R-9	
120	256	C	R-9	667
	(B475)			
120	256	BR	R-6	668
120	256	N	R-9	669
120	256	C-N	R-9	670
120	256	WM	R-9	
120	256	S	R-9	672
	(Over U.S. dime)			
120	434	C	R-9	
	(B467)			
120	434	BR	R-8	675
120	434	N	R-9	
120	434	C-N	R-7	677
120	434	WM	R-8	678
120	434	S	R-9	
121	Blank	BR	R-10	
121	Blank	S	R-10	
122	123	C	R-10	
122	462	C	R-8	
	(B638)			
124	177	C	R-9	
	(K206, DeW. AL 1864-53)			
124	177	N	R-9	
124	201	C	R-8	686
	(K196, DeW. AL 1864-46)			
124	201	BR	R-9	
124	201	N	R-8	688
124	201	C-N	R-9	689
	(Over C-N cent)			
124	201	WM	R-9	690

Obv.	Rev.	Metal	Rarity	H-G No.
124	201	GS	R-9	
124	201	S	R-9	
124	252	C	R-9	
	(K202, DeW. AL 1864-53D)			
124	294	C	R-7	
124	294	C-N	R-6	697
	(Over C-N cent)			
125	Blank	L	R-10	
125	160	C	R-9	
	(K203, DeW. AL 1864-50)			
125	160	BR	R-9	
125	160	N	R-9	
125	160	C-N	R-9	683
125	160	WM	R-9	
125	160	S	R-9	
125	185A	C	R-9	
125	201	C	R-8	
125	249	C	R-6	692
	(K197, DeW. AL 1864-47)			
125	249	BR	R-9	
125	249	N	R-9	
125	253	C	R-9	
	(K1039, DeW. AL 1864-53C)			
125	294	C	R-7	694
	(K200, DeW. AL 1864-48)			
125	294	BR	R-9	
125	294	N	R-9	696
125	294	C-N	R-8	
125	294	WM	R-9	698
125	294	GS	R-9	
125	294	S	R-9	
125	295	C	R-9	
	(K201, DeW. AL 1864-49)			
125	295	BR	R-9	
125	295	N	R-9	
125	295	C-N	R-9	
125	417	C	R-9	
	(K204, DeW. AL 1864-51)			
125	417	BR	R-8	
125	417	N	R-9	
125	417	C-N	R-9	703
	(Over C-N cent)			
125	417	C-N	R-9	
125	417	WM	R-9	
125	417	GS	R-9	
125	417	S	R-9	
125	428	C	R-9	
	(Zab 172, DeW. 1864-53F)			

Obv.	Rev.	Metal	Rarity	H-G No.
125	432	C	R-8	706
(K205, DeW. AL 1864-52)				
126	248	C	R-9	
(K222, DeW. AL 1864-62)				
126	294	C	R-9	
(K1036, DeW. AL 1864-64)				
126	295	C	R-5	708
(K223, DeW. AL 1864-63)				
126	295	BR	R-9	
126	295	N	R-9	
126	295	C-N	R-6	711
126	295	WM	R-9	
126	295	S'd	R-8	
126	295	S	R-9	
126	406A	C	R-9	
(K1037, DeW. AL 1864-66)				
126	432	C	R-9	
(K224, DeW. AL 1864-65)				
126	432	BR	R-9	
126	432	N	R-9	
126	432	C-N	R-9	717
(Over C-N cent)				
126	432	WM	R-9	
126	432	GS	R-9	
126	432	L	R-9	
127	160	C	R-9	
(K208, DeW. AL 1864-55)				
127	160	BR	R-9	
127	160	N	R-9	722
127	160	C-N	R-9	723
127	160	WM	R-9	
127	160	GS	R-9	
127	160	S	R-9	
127	177	C	R-9	
(K207, DeW. AL 1864-54)				
127	177	N	R-5	728
127	177	C-N	R-9	729
127	177	GS	R-7	
127	177	L	R-9	
127	185A	C	R-9	
(K213, DeW. AL 1864-61D)				
127	201	C	R-4	732
(K214, DeW. AL 1864-60)				
127	201	BR	R-9	
127	201	N	R-9	734
127	201	C-N	R-9	
127	201	WM	R-9	
127	201	GS	R-9	
127	201	S	R-9	
127	248	C	R-4	738
(K209, DeW. AL 1864-56)				
127	248	BR	R-3	739
127	248	N	R-7	
127	248	C-N	R-9	
127	248	WM	R-8	742
127	248	GS	R-9	
127	248	S	R-9	
127	252	C	R-9	
(K215, M725c, DeW. AL 1864-61C)				
127	252	BR	R-9	
127	252	N	R-9	
127	252	C-N	R-9	
127	252	WM	R-9	
127	253	C	R-9	
(K221, DeW. AL 1864-61G)				
127	294	C	R-9	744
(K210, DeW. AL 1864-57)				
127	294	BR	R-9	
127	294	N	R-8	746
127	294	C-N	R-9	
127	294	WM	R-9	
127	294	GS	R-9	
127	294	S	R-9	
127	295	C	R-9	
(K211, DeW. AL 1864-58)				
127	295	BR	R-9	
127	295	C-N	R-6	753
127	428	C	R-9	756
(K217, DeW. AL 1864-61F)				
127	428	BR	R-9	
127	428	N	R-9	
127	428	C-N	R-9	759
127	428	WM	R-8	760
127	428	S	R-9	
127	432	C	R-9	
(K212, DeW. AL 1864-52)				
128	289	C	R-9	
(K108, DeW. AL 1864-44)				
128	289	BR	R-3	
128	289	N	R-9	
128	289	C-N	R-9	
(Over C-N cent)				
128	289	G pl.	R-7	762
(Plated)				
128	289	S pl.	R-7	763
(Plated)				
128	289	GS	R-9	

Obv.	Rev.	Metal	Rarity	H-G No.
128	290	C	R-9	
(K109, DeW. AL 1864-45)				
128	290	BR	R-4	
128	290	N	R-9	
128	290	G pl.	R-7	764
(Plated)				
128	290	S pl.	R-8	
(Plated)				
129	Blank	C	R-10	
(K1042)				
129	130	C	R-10	
(K106, DeW. AL 1864-10)				
(Also known over 1855 cent)				
129	130	BR	R-10	
129	130	S	R-10	
129	137A	WM	R-9	
(K-877, DeW. AL 1864-74G)				
129	142	C	R-10	
(K193, DeW. AL 1864-41)				
129	142	BR	R-9	
129	142	S	R-10	
129	144	C	R-9	766
(K118, DeW. AL 1864-74E)				
129	144	WM	R-9	
129	153	C	R-9	
(K117, F.FR. T.NL.4)				
129	153	BR	R-9	
129	153	WM	R-9	
129	282	C	R-9	
(K115, DeW. AL 1864-75)				
129	282	BR	R-9	
129	282	WM	R-9	
129	347	C	R-9	
(K114, DeW. AL 1864-74)				
129	347	BR	R-9	
129	347	N	R-9	
129	347	WM	R-7	771
129	347	WM	R-9	
(Gold plated)				
129	348	WM	R-9	
129	348	S	R-9	
129	349	C	R-9	
(K120, DeW. AL 1864-77)				
129	349	BR	R-9	774
129	349	N	R-9	
129	349	WM	R-9	777
129	349	WM	R-9	
(Gold plated)				
129	349	WM	R-9	
(Silver plated)				
129	349	S	R-9	
129	349	C	R-8	
(Gilt)				
129	477	WM	R-9	
(K121, DeW. AL 1864-74F)				
130	142	BR	R-10	
(DeW. AL 1864-42)				
130	347	WM	R-9	
130	349	C	R-9	
(K122, DeW. AL 1864-78)				
130	349	BR	R-9	
130	349	WM	R-9	
130	349	WM	R-9	
(Gold plated)				
130	349	S	R-9	
131	217	C	R-8	
(K99, DeW. AL 1864-33)				
131	217	BR	R-8	
131	217	WM	R-8	
131	217	S	R-8	
131	479	C	R-8	
(K98, DeW. AL 1864-32)				
131	479	BR	R-8	
131	479	WM	R-8	
131	479	S	R-8	
(Plated)				
131	479	S	R-8	
131A	349A	C	R-8	
(K105, DeW. AL 1864-39)				
131A	349A	BR	R-7	
131A	349A	WM	R-8	
131A	349A	S pl.	R-6	
(Plated)				
131A	349A	S	R-9	
132	149	C	R-5	
(K226, DeW. AL 1864-68)				
132	149	BR	R-5	
132A	149	C	R-5	
(K225, DeW. AL 1864-67)				
132A	149	BR	R-5	
133	458	C	R-8	
(K107, DeW. AL 1864-33)				
133	458	BR	R-6	
133	458	C	R-8	
(Silvered)				
134	184	C	R-9	9710
134	184	BR	R-9	9711

Obv.	Rev.	Metal	Rarity	H-G No.
134	184	N	R-9	9712
134	184	GS	R-9	9713
134	184	L	R-9	9714
134	184	WM	R-9	
134	283	C	R-9	9691
134	283	BR	R-9	9692
134	283	N	R-9	9693
134	283	C-N	R-9	9694
134	283	GS	R-9	9695
134	283	L	R-9	9696
134	283	WM	R-9	
134	472	C	R-9	9636
134	472	BR	R-9	9637
134	472	N	R-9	9638
134	472	C-N	R-9	
134	472	GS	R-9	9639
134	472	WM	R-9	
134	472	L	R-9	9640
134	481	C	R-9	9630
134	481	BR	R-9	9631
134	481	N	R-9	9632
134	481	C-N	R-9	
134	481	GS	R-9	9633
134	481	L	R-9	9634
135	Blank	S	R-10	779
(Over U.S. dime)				
135	135 Incuse	C	R-9	780
135	199	C	R-8	782
135	199	BR	R-9	
135	199	N	R-9	
135	199	C-N	R-9	
135	199	C-N	R-9	
(Over C-N cent)				
135	199	WM	R-10	
135	199	S	R-10	
135	199	S	R-10	
(Over U.S. dime)				
135	440	C	R-2	784
135	440	C-N	R-9	
135	440	C-N	R-9	787
(Over C-N cent)				
135	440	WM	R-9	
135	441	C	R-2	
136	397	C	R-1	790
137	Plain	C	R-10	
137	309	C	R-9	792
137	395	C	R-1	794
138	Blank	C	R-9	
138	138 Incused		R-9	

Obv.	Rev.	Metal	Rarity	H-G No.
138	255	C	R-2	796
(DeW. GMcC 1864-34)				
138	255	BR	R-4	797
138	255	WM	R-9	
138	255	S	R-8	801
138	256	C	R-3	803
(DeW. GMcC 1864-35)				
138	434	C	R-1	805
(DeW. GMcC 1869-33)				
138	434	BR	R-6	806
138	434	N	R-8	
138	434	C-N	R-9	808
138	434	WM	R-8	809
138	434	GS	R-8	
138A	150	C	R-6	
(DeW. GMcC 1864-37)				
139	432	C	R-9	
140	140 Incuse	C	R-9	
140	187	L	R-9	
140	394	C	R-1	811
(DeW. GMcC 1864-31)				
140	394	BR	R-7	812
140	394	WM	R-9	815
140	394	S	R-9	
141	307	C	R-1	817
(DeW. GMcC 1864-32)				
141	307	BR	R-9	
141	307	C-N	R-9	
142	282	C	R-9	819
(DeW. GMcC 1864-39)				
142	282	BR	R-9	
142	282	N	R-9	
142	282	WM	R-9	
142	282	S	R-9	
142	347	C	R-8	821
(DeW. GMcG 1864-38)				
142	347	BR	R-8	
142	347	N	R-9	
142	347	WM	R-9	
142	347	S	R-9	
142	348	C	R-9	
142	348	WM	R-9	
142	348	G pl.	R-8	823
(Plated)				
142	348	S pl.	R-8	824
(Plated)				
142	349	C	R-9	
142	349	BR	R-9	
(DeW. GMcC 1864-40)				

Obv.	Rev.	Metal	Rarity	H-G No.	Obv.	Rev.	Metal	Rarity	H-G No.
142	349	WM	R-9		147	227	WM	R-8	
142	349	G pl.	R-9		147	227	S	R-9	
	(Plated)				147	228	C	R-7	
142	349	S pl.	R-9			DeW. C 1861-7)			
	(Plated)				147	228	BR	R-8	
142	349	S	R-9		147	228	WM	R-8	
143	261	C	R-1	826	147	228	S	R-9	
	(DeW. GMcC 1864-36)				151	430	C	R-1	832
143	261	BR	R-5	827		(F.FR. T.NL.1)			
143	261	N	R-9		151	430	BR	R-9	
143	261	WM	R-9		151	430	WM	R-9	
143	261	Lead	R-9		151	430	S	R-8	
	(Reeded edge)				152	Blank	C	R-10	
143	261	Lead	R-9	829	153	Blank	C	R-7	
143	261	S	R-7	830		(Over large cent, F.FR. T.NL.5)			
144	282	C	R-9		153	282	C	R-8	
144	282	WM	R-9			(F.FR. T.NL.2)			
144	349	BR	R-9		153	282	BR	R-9	
145	349	C	R-9		153	282	WM	R-9	
	(DeW. HS 1868-12)				154	154 Incuse	C	R-9	
145	349	BR	R-9		154	218	C	R-4	834
146	184	C	R-9	9656	154	417	C	R-7	
146	184	BR	R-9	9657	154A	469A	C	R-9	
146	184	N	R-9	9658	155	400	C	R-4	836
146	184	C-N	R-9		155	431	C	R-4	838
146	184	GS	R-9	9659	155	431	BR	R-9	
146	184	L	R-9	9660	156	Plain	C	R-10	
146	184	WM	R-9		157	425	C	R-9	
146	283	C	R-9	9650	158	424	C	R-9	840
146	283	BR	R-9	9651	159	Blank	C	R-10	
146	283	N	R-9	9652	159	469	C	R-8	8043
146	283	GS	R-9	9653	160	218	C	R-7	842
146	283	L	R-9	9654	160	218	BR	R-7	843
146	283	WM	R-9		160	218	N	R-9	844
146	472	C	R-9	9716	160	218	C-N	R-9	
146	472	BR	R-9	9717	160	218	WM	R-8	846
146	472	N	R-9	9718	160	218	S	R-8	847
146	472	C-N	R-9	9719	160	417	C	R-5	849
146	472	WM	R-9		160	417	BR	R-9	850
146	472	GS	R-9	9720	160	417	C-N	R-8	
146	472	S	R-9	9721	160	417	C-N	R-9	852
146	472	L	R-9			(Over C-N cent)			
147	Blank	BR	R-10		160	417	WM	R-8	853
	(DeW. C 1861-8)				160	417	S	R-8	854
147	227	C	R-8		162	338	C	R-5	856
	(DeW. C 1861-6)				162	338	S'd	R-5	
147	227	BR	R-6		163	352	C	R-2	860
147	227	BR	R-6		163	352	BR	R-9	
	(Silvered)				164	312	C	R-1	858

Obv.	Rev.	Metal	Rarity	H-G No.	Obv.	Rev.	Metal	Rarity	H-G No.
164	312	BR	R-9		177	271	N	R-7	
165	400	C	R-5	862	177	271	C-N	R-9	913
165	431	C	R-5		177	294	C	R-9	914
165	431	BR	R-6	864		(B483)			
166	432	C	R-4	866	177	295	C	R-9	915
167	318	C	R-3	868		(B482)			
167	435	C	R-7	870	177	432	C	R-9	
167	435	BR	R-8	871	178	266	C	R-3	917
167	435	N	R-9	872	178	266	BR	R-7	918
167	435	C-N	R-8	873	178	266	N	R-9	919
167	435	WM	R-8	874	178	266	C-N	R-8	
167	435	S	R-8	875	178	266	C-N	R-9	920
168	168 Incuse	C	R-9			(Over C-N cent)			
168	311	C	R-1	877	178	266	WM	R-8	921
168	311	BR	R-4		178	266	S	R-9	922
169	213	C	R-2	879		(Over U.S. dime)			
169	213	BR	R-3		178	266	S	R-9	
171	340	WM	R-9	883	178	267	C	R-1	924
171	428	C	R-7	881	178	267	BR	R-10	
171	428	BR	R-9			(Struck over 138/434)			
171	428	WM	R-9		178	267	BR	R-9	
172	429	C	R-4	885	178	267	N	R-9	
173	272	C	R-1	887	178	267	C-N	R-8	927
	(B476)					(Over C-N cent)			
173	272	S	R-9	889	178	267	WM	R-8	928
174	Blank	L	R-10		178	267	S	R-9	929
	(Die Trial)					(Over U.S. dime)			
174	189	C	R-10		178	267	S	R-8	
174	233	C	R-10		178	267	L	R-9	
174	272	C	R-1	893	180	341	C	R-1	931
	(B477)				180	341	BR	R-8	932
174	272	BR	R-8		180	341	N	R-9	
174	272	N	R-9		180	341	C-N	R-9	
174	272	C-N	R-9	895	180	341	C-N	R-8	933
175	232	C	R-5	891		(Over C-N cent)			
175	400	C	R-3	897	180	341	WM	R-8	934
	(B481)				180	341	S	R-9	
175	401	C	R-5	899	180	341	S	R-9	935
175	403	C	R-4	901		(Over U.S. dime)			
176	271	C	R-1	903	180	343	C	R-4	937
	(B478)				180	343	BR	R-8	938
176	271	BR	R-6	904	180	343	C-N	R-9	
176	271	N	R-8	905	180	343	C-N	R-9	940
176	271	C-N	R-9	906		(Over C-N cent)			
176	271	WM	R-8	907	180	343	WM	R-9	941
176	271	GS	R-9	908	180	343	S	R-9	942
177	177 Incuse	C	R-8	909	180	430	C	R-4	944
177	271	C	R-2	911	180	430	BR	R-8	945
	(B479)				180	430	N	R-9	946

Obv.	Rev.	Metal	Rarity	H-G No.	Obv.	Rev.	Metal	Rarity	H-G No.
180	430	C-N	R-9		191	443	N	R-9	
180	430	C-N	R-8	947	191	443	L	R-9	979
	(Over C-N cent)					(Reeded edge)			
180	430	WM	R-9	948	192	470A	C	R-9	
180	430	S	R-8		193A	470A	C	R-8	
180	430	S	R-9	949	194	424	C	R-9	
	(Over U.S. dime)				195	247	C	R-8	
181	343	C	R-7	951	195	376	C	R-4	981
181	343	BR	R-9	952	195	378	C	R-3	983
181	343	N	R-8	953	195	378	BR	R-9	984
181	343	C-N	R-9		195	378	N	R-9	
181	343	C-N	R-9	954	195	378	L	R-9	
	(Over C-N cent)				195	378	L	R-9	985
181	343	WM	R-8	955		(Reeded edge)			
181	343	GS	R-8		196	355	C	R-3	987
181	343	S	R-8	956	196	355	C-N	R-9	990
184	427	C	R-9	9669		(Over C-N cent)			
184	427	BR	R-9	9670	196	360	BR	R-9	
184	427	N	R-9	9671	197	378	C	R-5	992
184	427	C-N	R-9	9672	197	380	C	R-2	994
184	427	GS	R-9	9673	197	380	L	R-9	
184	427	L	R-9	9674	198	360	C	R-9	
184	427	WM	R-9		198	360	BR	R-9	
185A	295	C	R-9		198	360	N	R-8	997
185A	432	C	R-9		198	360	WM	R-9	
185B	Blank	C	R-10		198	436	C	R-9	
186	Blank	C	R-10		198	436	BR	R-9	
187	214	L	R-8	958	198	436	N	R-9	
187	214	L	R-9	959	198	436	WM	R-8	1001
	(Reeded edge)				199	359	WM	R-10	
187	450	C	R-9		199	360	WM	R-10	
187	476	L	R-9		199	440	WM	R-9	1005
188	384	C	R-2	961	200	346	C	R-8	1006
188	384	BR	R-8	962	200	346	WM	R-9	1010
188	384	N	R-9	963	201	201 Incuse	C	R-9	1012
188	384	L	R-9	966	201	271	BR	R-9	
188	435	C	R-8	968	201	271	WM	R-9	
188	435	BR	R-8	969	201	294	C	R-9	
188	435	N	R-8	970	201	295	C	R-9	
188	435	C-N	R-8	971	201	295	N	R-8	1015
188	435	WM	R-8	972	201	295	C-N	R-8	1016
188	435	S	R-8	973	201	432	C	R-3	1018
189	231	C	R-10		201	432	BR	R-9	
189	399	C	R-1	975	201	432	N	R-9	
189	399	BR	R-8	976	201	432	C-N	R-9	1021
190	432	WM	R-9		201	432	S	R-9	
190	432	S	R-9		202	434	C	R-1	1023
191	Incuse	C	R-9		202	434	BR	R-8	1024
191	443	C	R-1	978					

Obv.	Rev.	Metal	Rarity	H-G No.
203	412	C	R-2	1026
	(W-10)			
203	413	C	R-3	1027
	(W-11)			
203	413	BR	R-4	
203	413	S'd	R-4	
204	413	C	R-3	
	(W-15)			
205	410	C	R-3	1028
	(W-12)			
205	411	C	R-9	
	(W-17)			
206	320	C	R-2	1032
206	320	Bronze	R-3	
206	320	C	R-8	
	(Gilt)			
206	323	C	R-3	1034
207	323	C	R-2	
207	324	C	R-2	
207	325	C	R-4	
207	327	BR	R-7	
207	409	C	R-1	
	(W-2)			
207	409	BR	R-4	
207	410	C	R-1	
	(W-1)			
207	410	S'd	R-5	
	(Plated)			
207	412	C	R-1	
	(W-9)			
208	325	C	R-1	1036
208	410	C	R-1	1040
	(W-3)			
208	410	S'd	R-5	
	(Plated)			
209	409	C	R-7	1038
209	410	C	R-3	
	(W-7)			
209	410	BR	R-4	
209	412	C	R-3	1042
	(W-13)			
209	412	BR	R-4	
209	414	C	R-2	1043
	(W-6)			
210	323	C	R-1	1045
210	408	C	R-2	
	(W-8)			
210	408	Bronze	R-2	

Obv.	Rev.	Metal	Rarity	H-G No.
210	413A	BR	R-9	
	(W-19)			
210	415	C	R-3	1051
	(W-14)			
210	415	Bronze	R-3	
210	416	C	R-4	1053
	(W-16)			
210	416	Bronze	R-3	
210	416	BR	R-3	
211	400	C	R-2	1047
211	402	C	R-9	1049
212	415	C	R-2	1055
	(W-5)			
212	415	S'd	R-5	
	(Plated)			
213	213 Incuse	C	R-9	1056
214	415	C	R-9	
214	416	C	R-2	1057
214	416	Bronze	R-3	
214	416	BR	R-4	
215	416	C	R-5	
216	293	C	R-2	1059
217	479	C	R-7	
	(DeW. U 1862-6)			
217	479	Bronze	R-7	
217	479	BR	R-7	
217	479	WM	R-7	
217	479	S	R-9	
218	417	C	R-5	1061
218	417	BR	R-7	1062
218	417	N	R-9	
218	417	C-N	R-8	
218	417	C-N	R-8	1064
	(Over C-N cent)			
218	417	WM	R-7	1065
218	417	S	R-8	
218	417	S	R-9	1066
	(Over U.S. dime)			
219	320	C	R-1	1068
219	323	C	R-2	1070
219	323	BR	R-3	
220	220 Incuse	C	R-9	
220	322	C	R-1	1072
220	327	C	R-9	1073
221	324	C	R-1	1074
221	327	C	R-3	1076
221	327	BR	R-8	
222	325	C	R-2	1078

Obv.	Rev.	Metal	Rarity	H-G No.
222	325	BR	R-5	
223	328	C	R-2	1080
224	322	C	R-1	1082
224	325	C	R-3	1084
224	326	C	R-1	
224	327	C	R-8	
225	321	C	R-9	1086
225	327	C	R-1	1088
226	321	C	R-4	1090
226	321	BR	R-8	
229	359	C	R-9	1092
229	359	BR	R-9	1093
229	359	N	R-8	1094
229	359	C-N	R-10	
229	359	WM	R-8	1096
229	359	S	R-10	
229	360	C	R-8	1098
229	360	BR	R-8	1099
229	360	N	R-8	1100
229	360	C-N	R-10	
229	360	WM	R-10	
229	391	WM	R-9	
230	352	C	R-2	1104
230	352	BR	R-8	
231	231 Incuse	C	R-8	1106
231	352	C	R-1	1107
231	352	BR	R-9	
231	352	L	R-9	
231	399	C	R-10	
232A	403	C	R-9	
233	312	C	R-1	1109
233	312	BR	R-8	
233	312	L	R-9	1111
233	312	S	R-9	
233	Blank	L	R-10	
	(Die Trial)			
234	431	C	R-4	1113
235	269	C	R-2	1115
235	269	C-N	R-9	
236	426	C	R-1	1117
236	426	BR	R-7	1118
236	426	S'd	R-5	
237	423	C	R-1	1124
238	402	C	R-4	1120
238	402	BR	R-8	
238	405	C	R-3	1122
238	405	BR	R-8	
239	421	C	R-4	1126
239	422	C	R-2	

Obv.	Rev.	Metal	Rarity	H-G No.
240	Blank	WM	R-10	
240	240 Incuse	C	R-9	1130
240	337	C	R-1	1128
240	337	BR	R-4	1129
240	337	S	R-9	
240	341	C	R-1	1132
240	341	BR	R-9	
240	341	N	R-9	
240	341	C-N	R-9	
240	341	C-N	R-8	1135
	(Over C-N cent)			
240	341	WM	R-7	1136
240	341	S	R-8	1137
	(Over U.S. dime)			
240	341	S	R-8	
241	296	C	R-9	
	(An unusual muling)			
241	336	C	R-1	1139
241	336	BR	R-7	1140
241	336	N	R-9	
241	336	C-N	R-8	1142
241	336	WM	R-8	1143
241	336	S	R-9	1144
	(Over U.S. dime)			
241	336	L	R-8	
241	337	C	R-9	
241	337	BR	R-9	
241	337	C-N	R-9	
	(Over C-N cent)			
241	337	WM	R-9	
241	338	C	R-2	1146
241	338	BR	R-8	1147
241	338	N	R-9	1148
241	338	C-N	R-9	1149
241	338	WM	R-8	1150
241	338	GS	R-9	
241	338	S	R-9	
241	338	S	R-9	1151
	(Over U.S. dime)			
242	374	C	R-2	1153
242	374	C-N	R-9	
243	247	C	R-3	1155
243	247	BR	R-9	
243	247	C-N	R-9	
243	378	C	R-3	1171
243	378	BR	R-9	
243	378	L	R-9	
243	380	C	R-3	1173
244	291	C	R-2	1165

Obv.	Rev.	Metal	Rarity	H-G No.	Obv.	Rev.	Metal	Rarity	H-G No.
244	375A	C	R-1	1167	255	390	C	R-1	1209
244	381	C	R-1	1169		(B466)			
245	375	C	R-3		255	390	S'd	R-5	
247	377	C	R-2	1157	255	392	C	R-1	1211
247	379	C	R-3	1159	255	392	S	R-8	1216
247	379	C-N	R-9	1161	255	393	C	R-1	1218
	(Over C-N cent)				255	393	BR	R-3	1219
247	380	C	R-5	1163	255	393	C-N	R-9	1221
248	252	C	R-9			(Over C-N cent)			
	(M p.329 725f)				255	433	C	R-1	1224
248	295	C	R-9		255	433	WM	R-9	1228
248	428	C	R-9		256	433	C	R-3	1230
249	249 Incuse	C	R-9		256	433	BR	R-3	1231
249	271	C	R-4	1175	257	311	C	R-3	1233
249	271	S'd	R-5		257	311	BR	R-8	
249	432	C	R-3	1177	258	446	C	R-3	1235
249	432	BR	R-9		258	446	BR	R-9	
249	432	C-N	R-9			(Struck over Kingsley, Utica,			
249	432	C-N	R-9	1180		N.Y. token)			
	(Over C-N cent)				258	446	C-N	R-9	1238
250	437	C	R-7	1183		(Over C-N cent)			
251	345	C	R-5	1185	258	446	WM	R-8	1239
	(M 726k)				258	446	S	R-8	1240
252	271	C	R-4	1187		(Over U.S. quarter)			
	(M 725a)				258	446	S	R-8	1241
252	271	BR	R-5	1188		(Over English shilling)			
252	271	C-N	R-5	1190	259	445	C	R-3	1243
252	294	C	R-9		260	447	C	R-7	1245
	(M p.329 725e)				260	447	BR	R-7	1246
252	295	C	R-9		260	447	N	R-8	1247
	(M p.329 725d)				260	447	C-N	R-8	1248
252	432	C	R-8	1193	260	447	WM	R-9	1249
	(M 725b)				260	447	S	R-9	1250
252	432	BR	R-9	1194	260	447	L	R-9	
252	432	N	R-9	1195	260	447	GS	R-8	
252	432	C-N	R-8	1196	261 Incused	322	C	R-10	
252	432	WM	R-8	1197	266	Blank	C	R-10	
252	432	S	R-9	1198	271	Blank	C	R-10	1252
253	294	C	R-9		276	278	C	R-6	1254
253	432	C	R-9		281	Blank	C	R-9	
254	254 Incuse	C	R-9		281	468	BR	R-9	
254	255	C	R-1	1199		(Reeded)			
254	434	C	R-1	1201	283	427	C	R-9	9676
254	434	BR	R-4	1202	283	427	BR	R-9	9677
254	434	N	R-9		283	427	N	R-9	9678
254	434	WM	R-9	1205	283	427	C-N	R-9	9679
255	Blank	C	R-9		283	427	GS	R-9	9680
255	255 Incuse	C	R-9	1207	283	427	L	R-9	9681
					283	427	WM	R-9	

Obv.	Rev.	Metal	Rarity	H-G No.
284	463	L	R-9	
285	383	C	R-6	4323
286	382	C	R-7	6252
286	382	BR	R-7	6253
287	417	BR	R-9	5592
287	417	C-N	R-9	
287	417	WM	R-9	
287	520	BR	R-9	
294	428	C	R-9	
294	432	C	R-9	
295	295	C	R-9	
295	428	C	R-9	
295	432	C	R-4	1256
295	432	BR	R-9	
295	432	C-N	R-8	1258
299	350	C	R-2	1260
299	350	BR	R-7	1261
299	350	C-N	R-8	
299	350	C-N	R-7	1263
(Over C-N cent)				
299	350	WM	R-8	1264
299	350	S	R-9	
299	350	S	R-9	1265
(Over U.S. dime)				
305	350	C	R-9	
317	Blank	C	R-10	1267
328	328 Incuse	C	R-9	
332	336	C	R-4	1269
332	336	BR	R-8	1270
332	336	C-N	R-7	1272
332	336	WM	R-8	1273
332	336	S	R-8	
336	Blank	C	R-9	
336	337	WM	R-9	
337	350	C	R-2	1275
337	350	BR	R-9	
337	350	C-N	R-8	1278
(Over C-N cent)				
337	350	C-N	R-7	
337	350	S	R-9	
340	428	WM	R-9	
341	Blank	WM	R-10	
349	477	WM	R-9	
359	436	C	R-8	1281
359	436	BR	R-8	1282
359	436	N	R-8	1283
359	436	C-N	R-9	
359	436	WM	R-9	
360	436	C	R-9	1286

Obv.	Rev.	Metal	Rarity	H-G No.
360	436	BR	R-8	1287
360	436	N	R-8	1288
360	436	WM	R-8	
372	Blank	C	R-10	
372	faint flags	C	R-10	
(352?)				
372	Blank	S	R-10	
381	Blank	C	R-10	
386	427	C	R-8	9566
386	427	BR	R-8	9567
386	427	N	R-8	9568
386	427	C-N	R-8	9569
386	427	WM	R-8	
386	427	GS	R-8	9570
386	427	S	R-8	9571
386	427	L	R-8	9572
390	Blank	C	R-10	
390	390 Incuse	C	R-9	
390	434	C	R-3	1291
392	434	BR	R-9	
392	434	N	R-8	
392	434	WM	R-8	1294
392	434	GS	R-8	
393	393 Incuse	C	R-9	1296
396	396 Incuse	C	R-9	
398	398 Incuse	C	R-9	
410	Blank	C	R-10	
410	410 Incuse	C	R-9	1298
414	414 Incuse	C	R-9	
418	Blank	C	R-10	
424	451	C	R-10	
425	425	C	R-9	
427	Blank	C	R-10	
427	480A	C	R-9	9689
427	480A	BR	R-9	9690
427	472	C	R-9	
427	472	BR	R-9	
427	472	N	R-9	
427	472	C-N	R-9	
427	472	GS	R-9	
427	472	WM	R-9	
427	472	L	R-9	
427	472	S	R-9	
428	432	C	R-9	
433	434	BR	R-8	
433	434	N	R-8	1300
433	434	WM	R-9	1302
433	434	GS	R-9	
444	452A	BR	R-9	

Obv.	Rev.	Metal	Rarity	H-G No.	Obv.	Rev.	Metal	Rarity	H-G No.
449	471	C	R-2	9484	481	490	WM	R-8	
449	471	BR	R-2		481	491	C	R-8	
450	Blank	BR	R-9		481	491	BR	R-8	
450	471	C	R-1	9485	481	491	L	R-8	
450	471	BR	R-2		481	492	C	R-8	
454	454 Incuse	BR	R-9		481	492	BR	R-8	
457	457 Incuse	C	R-9		481	492	C-N	R-8	
460	460 Incuse	C	R-9		481	492	WM	R-8	
461	461 Incuse	C	R-9		481	492	L	R-8	
474	475	C	R-8		481	493	L	R-8	
478	480	C	R-10		481	493A	C	R-8	
481	482	C	R-8		481	493B	C	R-8	
481	482	BR	R-8		481	493B	BR	R-9	
481	482	C-N	R-8		494	495	C	R-9	
481	482	WM	R-8		496	497	BR	R-9	
481	482	L	R-8		498	499	Iron	R-8	
481	483	C	R-8		500	501	BR	R-8	
481	483	BR	R-8		500	504	BR	R-8	
481	483	C-N	R-8		500	505	BR	R-8	
481	483	WM	R-8		500	505A	BR	R-8	
481	483	L	R-8		502	503	BR	R-8	
481	484	C	R-8		506	507	C	R-8	
481	484	BR	R-8			(K66, F I/IA)			
481	484	WM	R-8		506	508	C	R-8	
481	484	L	R-8			(K63, F I/II, DeW. AL 1860-67)			
481	485	C	R-8		506	508	S'd	R-8	
481	485	BR	R-8		506	509	C	R-8	
481	485	N	R-8			(K62, F I/III, DeW. AL 1860-66)			
481	486	C	R-8		506	510	C	R-8	
481	486	BR	R-8			(K61, F I/IV, DeW. AL 1860-65)			
481	486	C-N	R-8		506	511	C	R-8	
481	486	WM	R-8			(K65, F IB/6, DeW. AL 1860-69)			
481	486	L	R-8		506	511	BR	R-8	
481	487	C	R-8		506	511	WM	R-9	
481	487	BR	R-8		506	512	C	R-8	
481	487	C-N	R-8			(K59, F IC/7, DeW. AL 1860-62)			
481	487	WM	R-8		506	512	BR	R-8	
481	487	L	R-8		506	512	S'd	R-8	
48I	488	C	R-8		506	513	C	R-8	
481	488	BR	R-8			(K60, F I/8, DeW. AL 1860-63)			
481	488	N	R-8		506	513	BR	R-8	
481	488	C-N	R-8		506	513	S'd	R-8	
481	488	L	R-8		506	514	C	R-8	
481	489	C	R-8			(K64, F I/9, DeW. AL 1860-68)			
481	489	BR	R-8		506	514	BR	R-8	
481	489	C-N	R-8		506	514	WM	R-9	
481	490	C	R-8		506	519	C	R-8	
481	490	BR	R-8			(K67, F I/Bl., DeW. AL 1860-64)			
481	490	C-N	R-8						

Obv.	Rev.	Metal	Rarity	H-G No.
507	508	C	R-8	
(K63A, F IA/II)				
507	509	C	R-8	
(K62A, F IA/III)				
507	510	C	R-8	
(K61A, F IA/IV)				
508	509	C	R-8	
(F II/III, DeW. J.BELL 1860-15)				
508	510	C	R-8	
(DeW. SD 1860-19)				
508	511	C	R-8	
(DeW. JCB 1860-61)				
508	512	C	R-8	
(F II/7, DeW. JCB 1860-9)				
508	513	C	R-8	
(DeW. JCB 1860-10)				
508	514	C	R-8	
(F II/9, DeW. JCB 1860-5)				
508	519	C	R-8	
(F II/Bl., DeW. JCB 1860-11)				
508	519	BR	R-8	
509	510	C	R-8	
(F III/IV, DeW. SD 1860-18)				
509	510	BR	R-8	
509	511	C	R-8	
(F III/6, DeW. J.BELL 1860-17)				
509	512	C	R-8	
(F III/7, DeW. J.BELL 1860-12)				
509	513	C	R-8	
(F III/8, DeW. J.BELL 1860-13)				
509	514	C	R-8	
(F III/9, DeW. J.BELL 1860-16)				
509	519	C	R-8	
(F III/Bl., DeW. J.BELL 1860-14)				
510	511	C	R-8	
(F IV/6, DeW. SD 1860-21)				
510	511	BR	R-8	
510	512	C	R-8	
(F IV/7, DeW. SD 1860-15)				
510	512	BR	R-8	
510	513	C	R-8	
(F IV/8, DeW. SD 1860-16)				
510	514	BR	R-8	
(F IV/9, DeW. SD 1860-20)				
510	519	C	R-8	
(F IV/Bl., DeW. SD 1860-17)				
511	512	C	R-8	
(F 6/7)				
511	513	C	R-8	
(F 6/8, DeW. JCB 1860-12)				
511	513	BR	R-8	
511	513	S'd	R-8	
511	513	WM	R-8	
511	514	C	R-7	
(F 6/9, DeW. JCB 1860-7)				
511	514	BR	R-4	
511	514	WM	R-8	
511	515	S'd	R-7	
(F 6/9A, DeW. JCB 1860-8)				
511	516	BR	R-5	
(F 6/9B)				
511	516	S'd	R-6	
511	517	BR	R-6	
(F 6/9C)				
511	518	BR	R-8	
511	519	C	R-8	
(F 6/Bl.)				
512	513	C	R-8	
(F 7/8)				
512	514	C	R-8	
513	514	C	R-8	
(F 8/9)				
513	519	C	R-8	
514	516	C	R-8	
(F 9/9B)				
514	516	BR	R-8	
514	519	C	R-8	
(F 9/Bl.)				
514	519	BR	R-8	
520	521	C	R-7	
(K83A)				

PLATE I

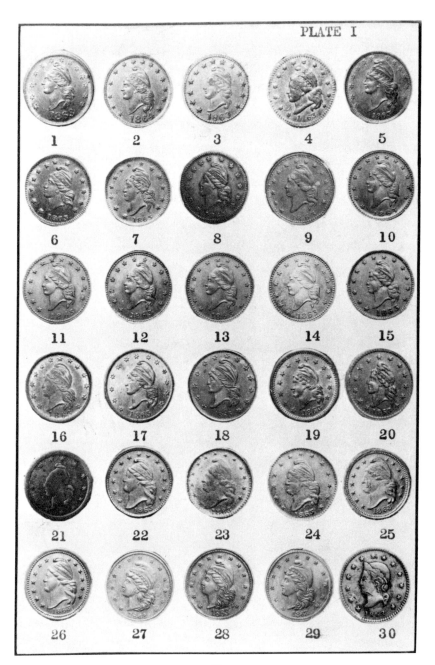

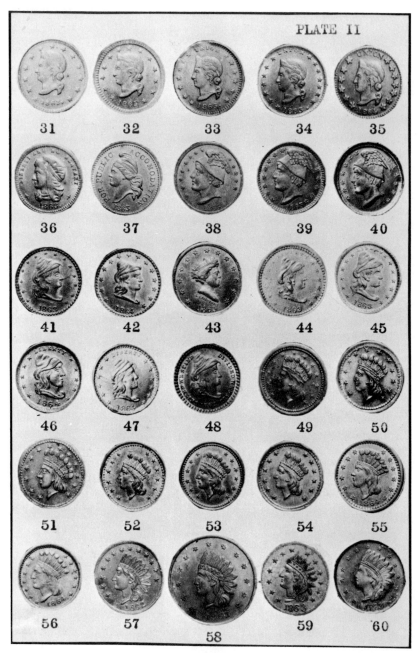

PLATE II

31 32 33 34 35

36 37 38 39 40

41 42 43 44 45

46 47 48 49 50

51 52 53 54 55

56 57 59 60

58

PLATE III

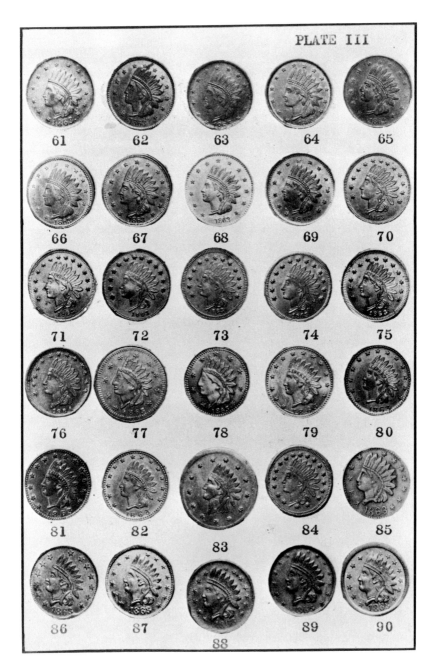

61 62 63 64 65

66 67 68 69 70

71 72 73 74 75

76 77 78 79 80

81 82 83 84 85

86 87 88 89 90

PLATE IV

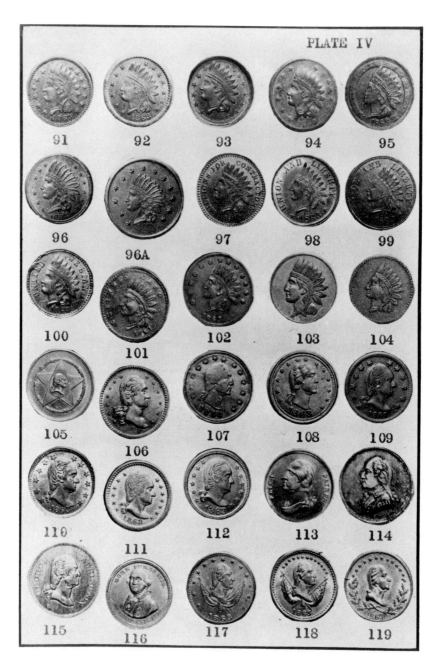

91 92 93 94 95

96 96A 97 98 99

100 101 102 103 104

105 106 107 108 109

110 111 112 113 114

115 116 117 118 119

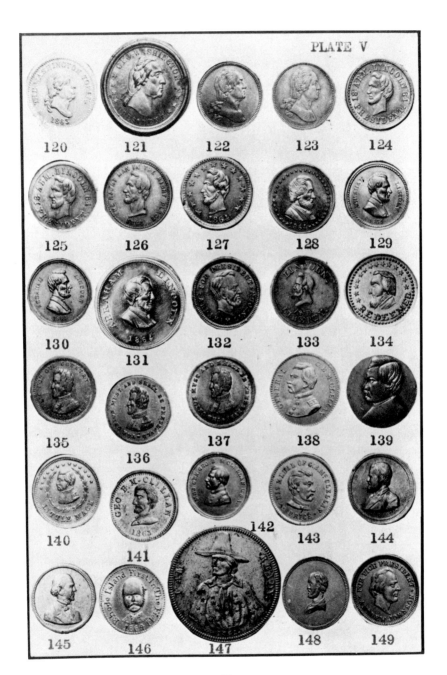

PLATE V

120 121 122 123 124

125 126 127 128 129

130 131 132 133 134

135 136 137 138 139

140 141 142 143 144

145 146 147 148 149

PLATE VI

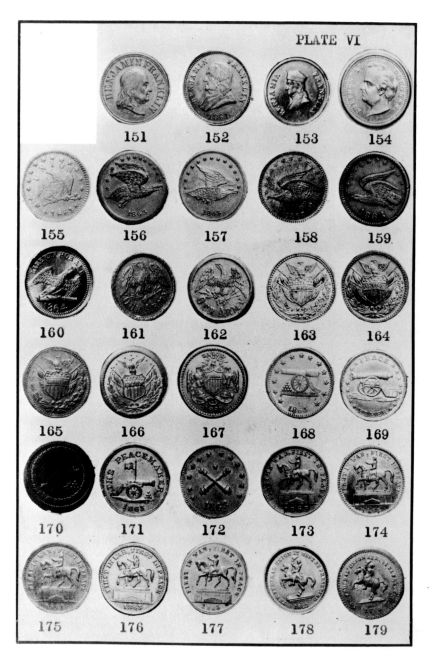

PLATE VII

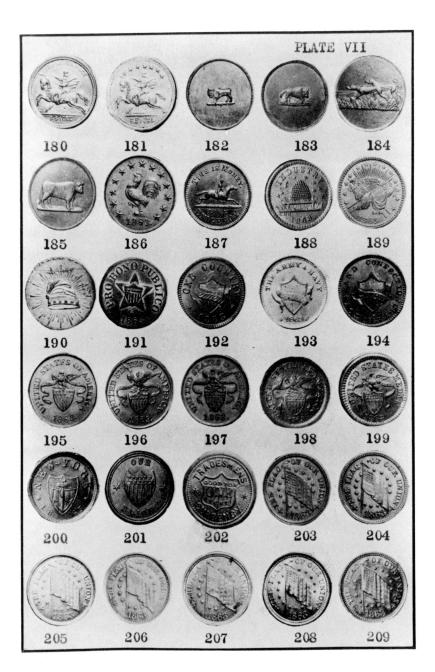

180 181 182 183 184

185 186 187 188 189

190 191 192 193 194

195 196 197 198 199

200 201 202 203 204

205 206 207 208 209

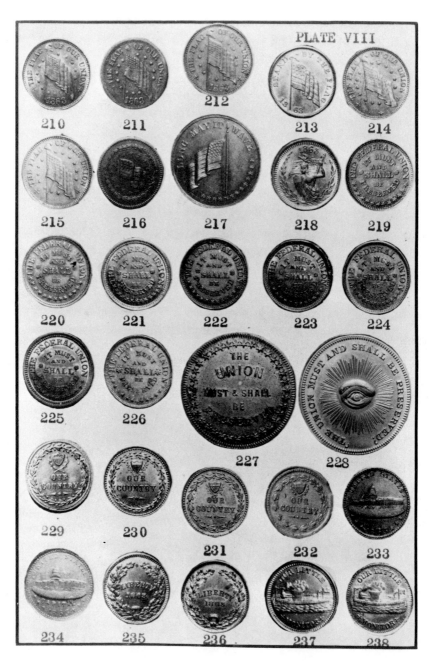

PLATE VIII

210 211 212 213 214

215 216 217 218 219

220 221 222 223 224

225 226 227 228

229 230 231 232 233

234 235 236 237 238

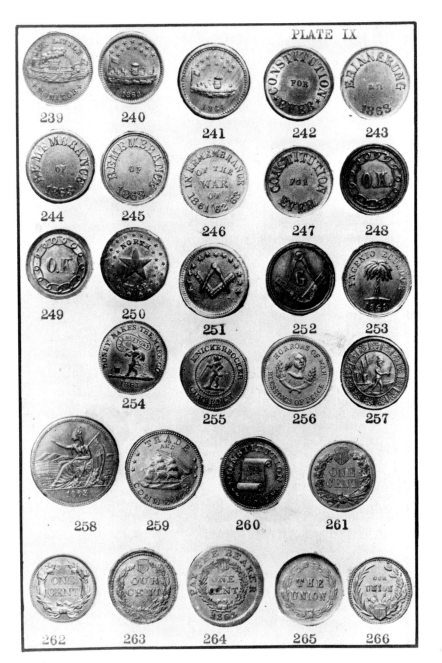

PLATE IX

239　240
241　242　243

244　245
246　247　248

249　250
251　252　253

254
255　256　257

258　259　260　261

262　263　264　265　266

PLATE X

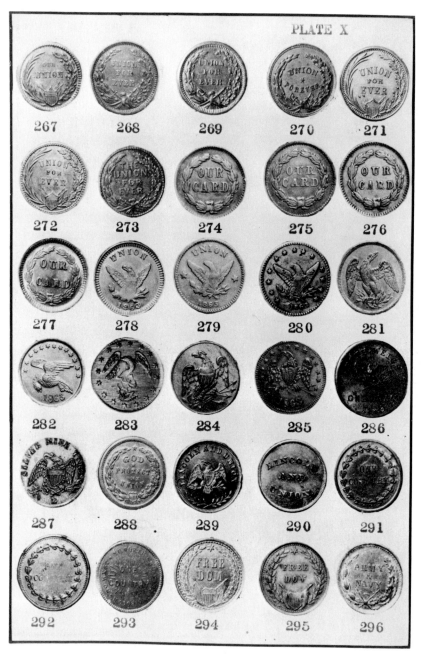

PLATE XI

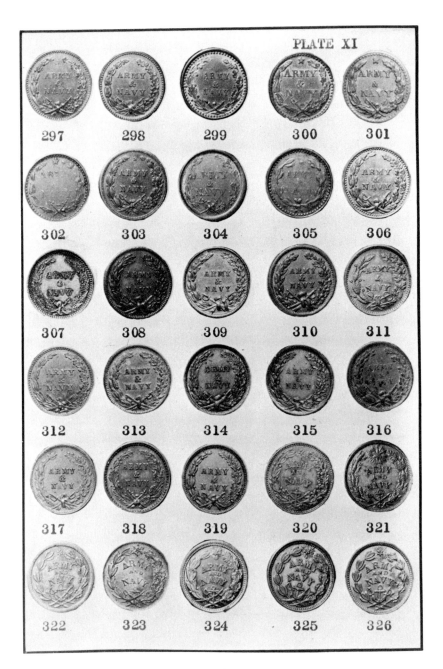

297 298 299 300 301

302 303 304 305 306

307 308 309 310 311

312 313 314 315 316

317 318 319 320 321

322 323 324 325 326

PLATE XII

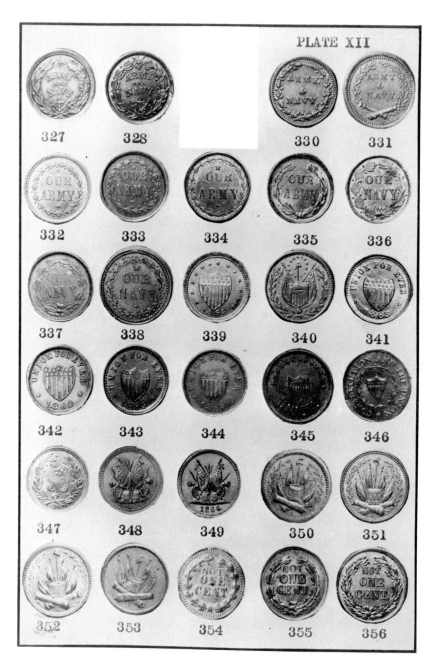

PLATE XIII

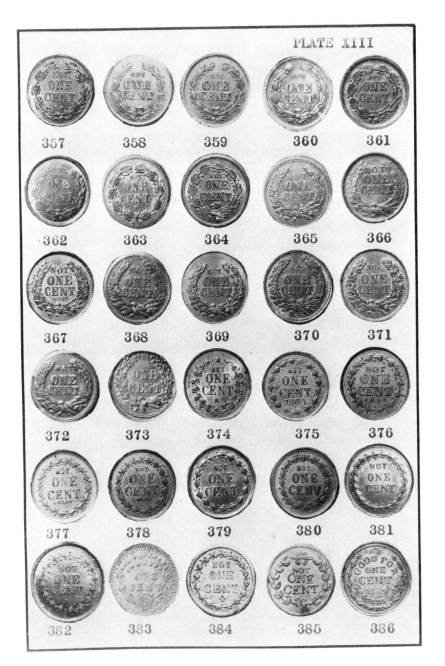

357 358 359 360 361

362 363 364 365 366

367 368 369 370 371

372 373 374 375 376

377 378 379 380 381

382 383 384 385 386

PLATE XIV

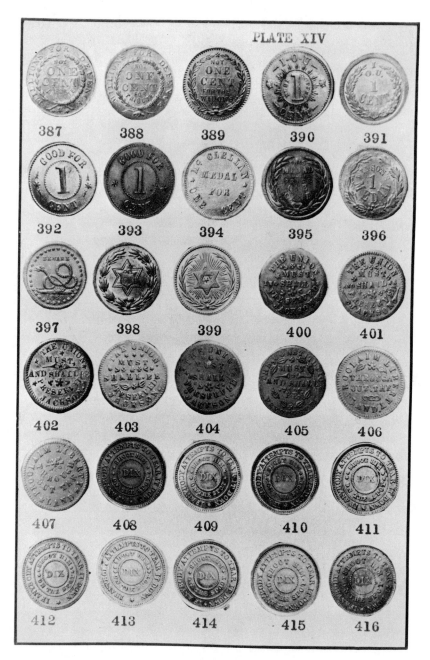

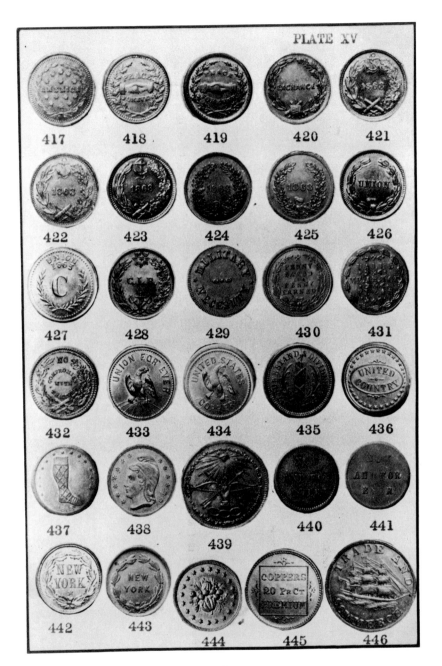

PLATE XV

417 418 419 420 421
422 423 424 425 426
427 428 429 430 431
432 433 434 435 436
437 438 439 440 441
442 443 444 445 446

—47—

PLATE XVI

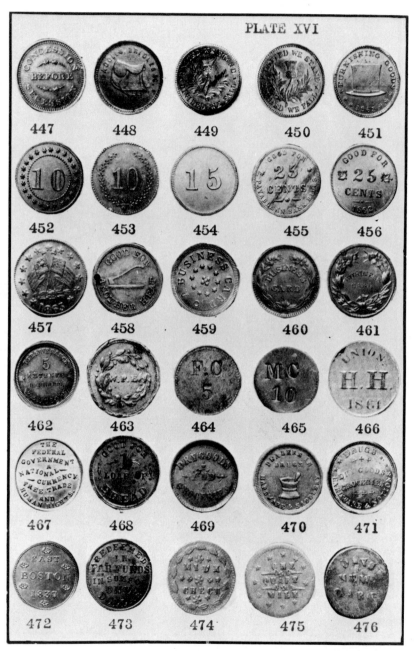

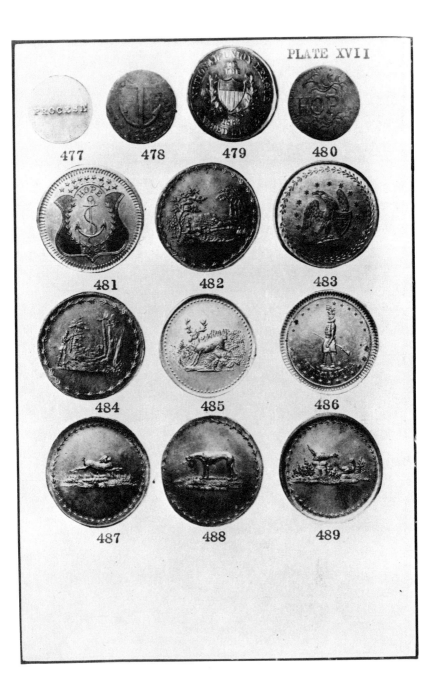

PLATE XVII

477 478 479 480

481 482 483

484 485 486

487 488 489

—49—

PLATE XVIII

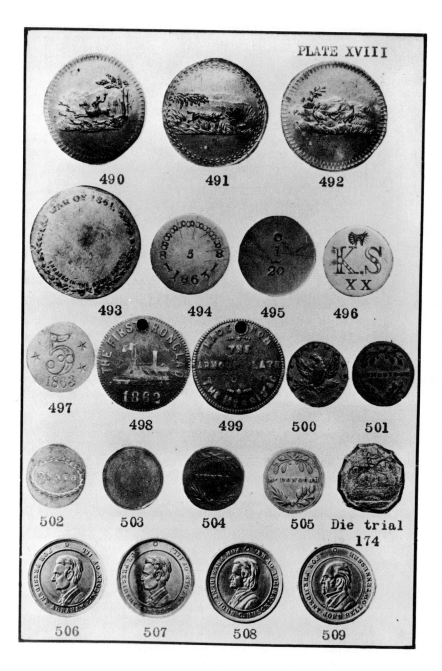

490 491 492

493 494 495 496

497 498 499 500 501

502 503 504 505 Die trial
174

506 507 508 509

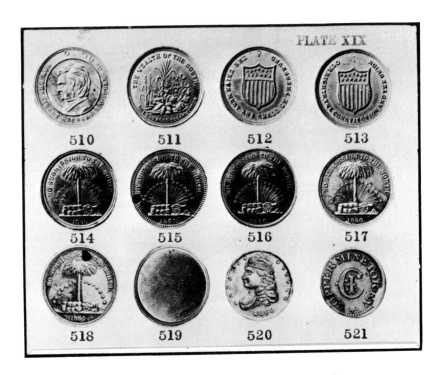

PLATE XIX

510 511 512 513

514 515 516 517

518 519 520 521

PLATE XX

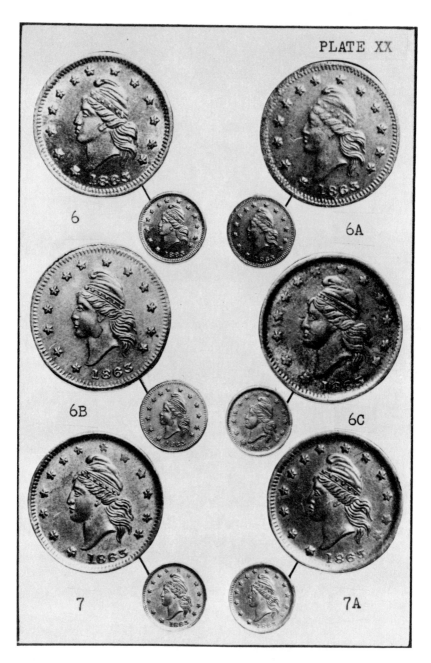

PLATE XXI

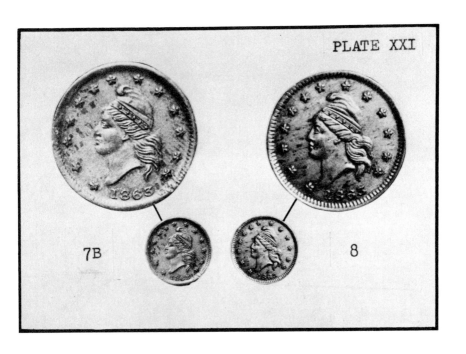

7B 8

#65A #232A

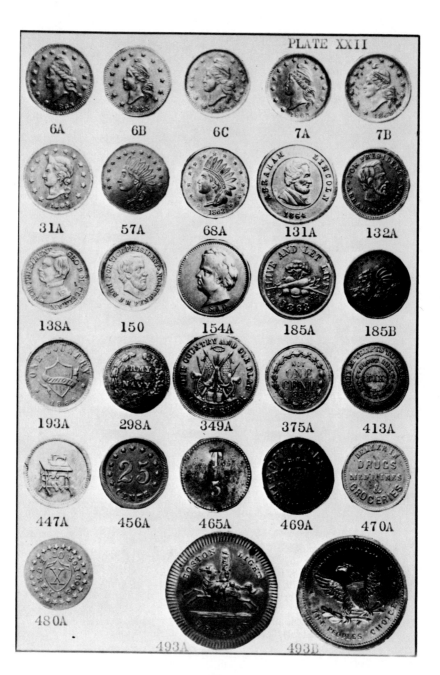

PLATE XXII

6A 6B 6C 7A 7B

31A 57A 68A 131A 132A

138A 150 154A 185A 185B

193A 298A 349A 375A 413A

447A 456A 465A 469A 470A

480A 493A 493B

APPENDIX

By the game of Civil War "mumbly peg" previously alluded to, the following list of die sinkers was compiled with the dies attributed to them. In the case where the engravers are unknown, the pieces that are of one manufacture are listed with the probable location.

1. Issued by Bridgens, 189 William Street, New York.
37, 120, 138, 202, 254, 255 (Bridgens), 256, 257, 390, 392, 393, 433, 434.

2. Issued by Childs, 117½ Randolph Street, Chicago, Illinois.
30, 31, 31A, 32, 33, 34, 35, 265, 274, 275, 276, 277, 278, 279, 280.

3. Issued by E. L. Eichtweis, New York.
17, 43, 52, 387, 388.

4. Issued by A. W. Escherich, 404 Clark Street, Chicago, Illinois.
101, 104, 263.

5. Issued by A. Gleason, Hillsdale, Michigan.
172, 285, 383, 429.

6. Issued by J. A. Hughes, Cincinnati, Ohio.
38, 156, 157, 425, 438 (Lutz).

7. Issued by Johnson, 154 Everett Street, Cincinnati, Ohio.
251, 345.

8. Issued by Key, Philadelphia, Pennsylvania.
96 (Key), 96A (Key), 116, 129 (K), 130 (K), 131, 131A, 142, 144, 145, 153, 217, 282, 284, 347, 348, 349, 349A, 463, 477, 479.

9. Issued by F. X. Kohler, Baltimore, Maryland.
3, 273, 464, 465, 465A.

10. Issued by W. K. Lanphear, 134 West 4th Street, Cincinnati, Ohio.
39, 40, 158, 159, 185B, 192, 193, 193A, 194, 424, 447A, 448, 451, 469, 470A.

11. Issued by Mossin and Marr, Milwaukee, Wisconsin.
154, 154A, 160*, 218, 417*, 469A.
The (*) pieces were muled with one of the unknown groups of New York.

12. Issued by Jas. Murdock, John Stanton and Spencer, 139 West 5th Street, Cincinnati, Ohio.
57, 57A, 70, 71, 72, 73, 74, 75, 76, 84, 148, 182, 183, 185, 281, 444, 444A, 452, 452A, 454, 455, 456, 456A, 456B, 459, 467, 468, 470, 473.

13. Issued by L. Roloff, E. Sigel, and C. D. Horter operating under single firm (?), New York.
1, 16, 18, 41, 42, 44, 45, 46, 47, 48, 49, 50, 51, 52, 53, 54, 55, 56, 58 (Roloff), 61 (Sigel), 62, 63, 68, 68A, 69, 92, 95, 98, 99, 100, 103, 105 (Sigel), 119, 135, 151, 161, 162, 179, 180 (Sigel), 181 (Sigel), 191, 195, 196, 197, 198, 199, 216, 229, 240 (Horter), 241, 242, 243, 244, 245, 247, 268 (Sigel), 291, 292, 293, 296, 299, 300, 301, 302, 304, 305, 332, 333, 334, 335, 336, 337, 338, 339, 341, 342, 343, 344, 350, 353, 355, 358, 359, 360, 366, 367, 368, 369, 374, 375, 375A, 376 (Sigel), 377 (Roloff), 378, 379, 380, 381, 391, 398, 430, 436, 439, 440, 441, 443.

14. Issued by Scovill Manufacturing Co., Waterbury, Conn.
Engraved possibly by Darwin Ellis who might have moved (with dies)
from around Mishawka, Indiana.
10, 11, 12, 13, 14, 79, 80, 81, 82, 141 (?), 163, 164, 173, 174, 189, 230,
231, 233, 236, 237, 239 (?), 272, 297, 298, 307 (?), 312, 351, 352, 399, 421,
422, 423 (?), 426, possibly 260 and 447.

15. Issued by engraver around Mishawka, Indiana (possibly Darwin Ellis)
who used many of the identical hubs when he moved to Waterbury.
9, 85, 155, 165, 175, 211, 232, 232A, 234, 238, 298A, 400, 401, 402, 403, 404,
405, 406, 407, 431.

16. Issued by B. F. True, Cincinnati, Ohio. See "The Numismatist," Vol. 54,
page 924 (1941).
506, 507, 508, 509, 510, 511, 512, 513, 514, 515, 516, 517, 518, 519.

17. Issued by unknown engraver in Providence, Rhode Island by order of
A. V. Jencks, Providence. See W. C. Woodward Sale No. 15, Dec. 10, 1866.
134, 146, 184, 283, 386, 427, 472, 480A, 481, 482, 483, 484, 485, 486, 487,
488, 489, 490, 491, 492, 493, 493A, 493B.

18. Issued by unknown engraver, probably in or around New York.
22, 25, 26, 109, 110, 118, 262, 418, 419, 442.

19. Issued by unknown engraver, possibly in New York.
60, 200, 346.

20. Issued by unknown engraver, possibly in Philadelphia (contains one
Sigel, Herter and Roloff die which were probably engraved by contract).
20, 23, 28, 29, 36, 91, 106 (L.R.), 107, 108, 111, 113, 114, 124, 125, 126,
127, 139, 166, 167, 171, 176, 177, 185A, 188 (C.D.H.), 190, 201, 248, 249,
252, 253, 271, 294, 295, 303 (E.S.), 306, 318, 340, 373, 384, 428, 432, 435.

21. Issued by unknown engraver, probably around New York.
6, 6A, 6B, 6C, 7, 7A, 7B, 8, 64, 137, 140, 235, 268, 269, 308, 309, 310, 313,
314, 315, 316, 317, 363, 394, 395.

22. Issued by unknown engraver, possibly Scovill Manufacturing Co.
Waterbury, Conn. but this attribution is highly questionable.
187, 206, 210, 212, 214, 215, 219, 220, 221, 222, 223, 224, 225, 226, 320,
321, 322, 323, 324, 325, 326, 327, 328, 329, 408, 415, 416, 476.

23. Issued by unknown engraver, possibly Benedict and Burnham, Water-
bury, Conn., although this attribution is highly questionable.
203, 204, 205, 207, 208, 209, 409, 410, 411, 412, 413, 413A, 414.

24. Issued by Robert Lovett, Philadelphia. 132, 132A, 138A, 149, 150.

Note: There are at least 37 other combinations of from 2 to 4 dies each
whose engraver cannot be determined. At present these pieces will not
be listed.

TABLE II

Key to New List of Dies as Compared to Hetrich & Guttag Die Numbers

Old Obv. (H.&G.)	New Obv.	Old Obv. (H.&G.)	New Obv.	Old Obv. (H.&G.)	New Obv.
1	1	46	56	91	110
2	3	47	58	92	111
3	4	48	59	93	112
4	5	49	60	94	113
5	6	50	61	95	116
6	10	51	62	96	117
7	12	52	63	97	118
8	15	53	64	98	119
9	16	54	66	99	120
10	17	55	67	100	124
11	18	56	68	101	126
12	19	57	69	102	127
13	20	58	70	103	128
14	13	59 (same as 405)	71	104	129
15	14	60 (same as 412)	73	105	135
16	22	61	77	106	136
17	23	62	78	107	137
18	24	63	79	108	138
19	25	64	80	109	140
20	31	65	81	110	141
21	32	66	82	111	142
22	27	67	83	112	143
23	28	68	84	113	144
24	29	69	85	114	151
25	33	70	86	115	154
26	34	71	87	116	155
27	35	72	88	117	158
28	36	73	89	118	160
29	37	74	90	119	161
30	38	75	91	120	162
31	41	76	92	121	163
32	42	77	93	122	166
33	43	78	94	123	167
34	44	79	95	124	168
35	45	80	96	125	169
36	46	81	97	126	171
37	47	82	98	127 (same as old 126)	
38	48	83	100	128	172
39	49	84	101	129	173
40	50	85	103	130	174
41	51	86	104	131	176
42	52	87	105	132	177
43	53	88	106	133	178
44	54	89	107	134	179
45	55	90	109	135	180

Old Obv. (H.&G.)	New Obv.	Old Obv. (H.&G.)	New Obv.	Old Obv. (H.&G.)	New Obv.
136	181	184	252	231	312
137	187	185	254	232	313
138	188	186	255	233	314
139	189	187	256	234	315
140	191	188	257	235	316
141	195	189	258	236	317
142	196	190 not on		237	318
143	198	patriotic token		238	319
144	199	191	259	239	320
145	200	192	260	240	321
146	201	193	261	241	322
147	202	194	262	242	323
148	203	195	263	243	325
149	205	196	264	244	327
150	206	197	265	245	328
151	208	198	266	246	330
152	210	199	267	247	331
153	212	200	268	248	332
154	213	201	269	249	334
155	214	202	271	250	335
156	216	203	272	251	336
157	218	204	273	252	337
158	219	205	274	253	338
159	220	206	275	254	339
160	221	207	277	255	340
161	222	208	278	256	341
162	224	209	279	257	342
163	225	210	281	258	343
164	226	211	282	259	345
165	229	212	288	260	346
166	230	213	289	261	347
167	231	214	290	262	348
168	233	215	291	263	349
169	234	216	293	264	350
170	235	217	294	265	351
171	236	218	295	266	352
172	237	219	296	267	353
173	239	220	297	268	354
174	240	221	298	269	355
175	241	222	299	270	356
176	242	223	300	271	357
177	243	224	303	272	358
178	244	225	306	273	359
179	246	226	307	274	360
180	247	227	308	275	361
181	248	228	309	276	362
182	250	229	310	277	363
183	251	230	311	278	364

Old Obv. (H.&G.)	New Obv.	Old Obv. (H.&G.)	New Obv.	Old Obv. (H.&G.)	New Obv.
279	365	327	421	501	182
280	366	328	423	502	183
281	367	329	424	504	184
282	368	330	426	507	185
283	369	331	428	509	185B
284	370	332	429	512	186
285	372	333	430	515	383
286	373	334	431	516	382
287	374	335	432	520	447A
288	375	336	434	530	470
289	376	337	435	555	448
290	377	338	436	556	451
291	378	339	437	566	185A
292	379	340	438	575	461
293	380	341	439	577	459
294	381	342	440	581	427
295	384	343	442	582	425
296	385	344	443	586	457
297	387	345	444	597	452
298	388	346	445	599	455
299	389	347	446	601	449
300	390	348	447	602	450
301	391	401	57A	608	456A
302	392	402	57	611	280
303	393	405 (same as 59)	71	628	30
304	394	406	72	645	433
305	395	412 (same as 60)	73	654	287
306	396	414	74	655	460
307	397	418	75	657	156
308	398	419	76	658	122
309	399	434	31A	670	157
310	400	442	40		
311	401	446	39		
312	402	461	192		
313	403	463	193		
314	405	464	194		
315	406	465	193A		
316	407	472	285		
317	408	477	283		
318	409	479	159		
319	410	486	286		
320	412	489	121		
321	414	491	115		
322	415	493	134		
323	416	494	152		
324	417	495	148		
325	418	496	146		
326	420	497	145		

TABLE III

Key to Turban Heads — Dies 6 through 8
(See enlargements on Plate XX and XXI)

Die	Number of ends to bottom curl	Number of ends to 2nd from bottom curl	Remarks
6	2	2	Top of turban almost under center of top star
6A	3	2	Struck in low relief
6B	3	3	Struck in low relief
6C	3	2	"1" of 1863 reads "I"
7	3	2	7 stars in head band
7A	3	3	Top of turban shows no "roll-back"
7B	2	3	Top of turban shows large "roll-back"
8	1	1	Only piece with single curl ends

TABLE IV

Key to Turban Heads — Dies 9 through 15

Die	Position of ends of bottom curl over date	Position at top of turban under 7th star	Position of tip of bust	Remarks
9	Between 6 and 3 of 1863	Under center of star	Far from 1st star—over 1	Struck always without collar
10	Between 6 and 3 of 1863	Under center of star	Far from 1st star—over 1	Die is concave near date
11	Almost to right side of 6 of 1863	Under center of star	Far from 1st star—over 1	6 close to 3 usually with die break through top stars
12	Closer to left side of 3 than center between 6 and 3	Under right side of star	Close to 1st star	

13	Over center of 3 of 1863	Towards left center of star	Far from 1st star—over 1	Dash (-) over 3!!
14	Over center of 3 of 1863	Towards right center of star	Very close to 1st star	
15	Between 6 and 3 of 1863	Under right side of star	Close to 1st star	Head has unusual expression— puffed cheeks and smile

TABLE V

Key to Plume Feather Headdress — Dies 49 through 56

Die	Position of 6th star clockwise	Point of bust	Remarks
49	Points between 2nd and 3rd plume	Very near border	5th star very near 1st plume
50	Points to center of of 2nd plume	Very near border	5th star far from 1st plume
51	Points to left side of 2nd plume	Far from border	Large nose—features differ from all others
52	In horizontal line with 1st plume	Far from border	Die break over 1st plume like (-)
53	In horizontal line with 1st plume	Far from border	First feather only half formed especially on left side
54	Below horizontal line with 1st plume	Far from border	
55	In horizontal line with 1st plume	Over 1 of 1864	Dated 1864
56	Far below horizontal line with 1st plume	Very near 1st star	Dated 1864

TABLE VI

Key to Indian Head Dies — Liberty on Head Bands

Die	Date	Position of last feather in relation to last star	Position of 2nd to last feather in relation to stars	End of ribbon points to date	Date
57	1862		Below last star	Over right center 8	Large date
57A	1862		Points to last star	Over right center 8	Large date
58	1863	Above last star Large size; L. Roloff	Between 2nd & 3rd star	To center 6	Large date
70	1863	Below last star	Just above last star	To center 6	Far from bust
71	1863		Just below last star	Over center 6	Far from bust
72	1863		Below last star Die break from bust top to border	Between 8 & 6	Far from bust
73	1863	Below last star	Just above last star	Over center 6	Bust touches 1
74	1863	Below last star	Just above last star	To left center 6	Far from bust
75	1863	Below last star	Just below 2nd star	To left 6	Near bust
76	1864	Below last star	Points to last star	To left 6	Far from bust
79	1863	Just below last star	Just below 2nd to last star	Between 8 & 6	8 and 6 far apart
		Die break through date			
80	1863	Below last star	Below 2nd to last star	To left 6	Near border
83	No date	2 stars under bust			No date
84	No date	2 stars under bust			No date

TABLE VI — Continued

Die	Date	Position of last feather in relation to last star	Position of 2nd to last feather in relation to stars	End of ribbon points to date	Date
104	No date				No date
		No stars			
96	1864				
		KEY PHILA on head band			
96A	No date				
		KEY PHILA on head band			
97	1863				
		FORT LAFAYE on head band			

TABLE VII

Key to Indian Head Dies — Balls in Head Band

Die	Date	Balls in head band	Period after star	End of ribbon points	Stars divided by head	End of bust
59	1863	8	No	To right side 6	Yes	Ends directly over 1
		Very narrow head				
60	1863	19	No	Over center 6	No	Between 1st star & 1
		Head off center to right				
61	1863	17	Yes	To center 6	No	Ends over 1
		E.S. below feathers				
62	1863	15	No	To left of 3	No	Ends over 1
		E.S. above right of date				
63	1863	17	Yes	To right center 6	No	End to left of 1
64	1863	16	No	Between 8 & 6	No	Far to left of 1
65	1863	17	No	To left center 6	No	To left of 1
65A	1863	12	No	To left center 6	No	To left of 1
66	1863	16	No	To left center 6	No	Between 1st star & 1
67	1863	14	No	To right side 6	No	Just to left of 1
68	1863	16	No	Between 8 & 6	No	Far to left of 1
68A	1863	17	No	To left 6	No	Far to left of 1
69	1863	17	No	To left 6	No	Ends over 1
77	1863	7	No	Over center 8	Yes	Over edge of 1
		Diamonds, no balls				
78	1863	7	No	Over center 8	Yes	Over edge of 1
		Diamonds, no balls				

81	1863	13	No	To left 6		No	Over edge of 1
	Die break through date						
82	1863	13	No	To left 6		No	Over edge of 1
95	1863	13	No	To left 6		Yes	To left of 1
	Stars set in ribbon						
98	1863	13	No	To left 6			Over star
	UNION AND LIBERTY around—no denticles						
99	1863	13	No	To left 6			Over star
	UNION AND LIBERTY around—denticles						
103	No date	16					
	No stars						

TABLE VIII
Key to Indian Head Dies — Plain Head Band

Die	Date	Position of last feather	Stars divided by head	Top right star in relation to feathers	Remarks
85	1863	To 2nd star	Yes	Over 3rd feather	'Ugly' head
86	1863	To last star	Yes	Over 2nd feather	Die break below 3
87	1863	Between last & 2nd star	Yes	To right 2nd feather	"H" above date
88	1863	To right center last star	Yes	Over 3rd feather	Band made of two rows of balls
89	1863	To left 2nd star	Yes	To right 2nd feather	
90	1863	To right center last star	Yes	To right 2nd feather	Head intercepts date
91	1863	To left 2nd star	Yes	Between 3rd & 4th feather	
92	1863	To right last star	Yes	Over left 3rd feather	
93	1863	Between last & 2nd star	Yes	To right 3rd feather	
94	1863	Below last star	Yes	Between 3rd & 4th feather	

100	1863	No stars		UNITED WE STAND around head
101	1861	No stars		BUSINESS CARD around head
102	1863	Below last star	No	

TABLE IX*

Key to Flag Tokens ("Dix" obverses) — Dies 203 through 218

Die	Number of stars in flag	Number of bars in flag	Cap shape	End of pole in relation to 1	Shape of right bottom end of flag	Position of top right star
203	25	5	Short, round, convex	Even with base	Very slight fold	Opposite 1st bar
204	25	5	Long, thin concave	About midway up side	Almost straight	Between 1st bar and space below
205	25	6	Long, thin concave	Even with base, very close	Moderate bulge	At corner of flag
206	25	6	Long, thin concave	Opposite end of top serif	Slight inward dip	At corner of flag
207	25	6	Long, thin convex	Even with base	Heavy bulge	Opposite 1st bar
			2nd star down & 2nd star in from upper left recut			
208	26	6	Long, thin pointed	Just above base	Almost straight	Slightly below 1st bar
209	25	6	Long, thin pointed	About ⅓ up side	Slight bulge	Opposite 1st bar
210	36	5	Short convex	Even with base	Short inward dip	Slightly below 1st bar

TABLE IX — Continued

Die	Number of stars in flag	Number of bars in flag	Cap shape	End of pole in relation to 1	Shape of right bottom end of flag	Position of top right star
211	36	5	Short convex	Even with base	Short inward dip	Slightly below 1st bar
			Same hub as 210, but no raised rim			
212	30	6	Short convex	Just **below** base	Very slight bulge	Opposite 2nd bar
213	12	5	Thick concave	**Divides** date	Straight	No stars
			STAND BY THE FLAG around			
214	25	6	Short convex	No date	Heavy bulge	Opposite 2nd bar
			No date, diamond below			
215	25	6	Short convex	No date	Heavy bulge	Opposite 2nd bar
			Same as 215, **no** diamond			
216	16	5	NO CAP	No date	Irregular	Below 1st bar
			Flag in wreath, 13 stars inside			
217	30	7	NO CAP	No date	Straight	No stars above
			LONG MAY IT WAVE around			
218	20(?)	6	Stubby cap(?)	Date above flag	Moderate bulge	No stars above
			Warrior with flag over shoulder			

* We wish to thank Richard Picker for help in assembling this table.

TABLE X*

Key to "The Federal Union Must and Shall Be Preserved"

Dies 219 through 226

Die	Position of "I" of IT relation to FEDERAL	Position of "P" of PRESERVED in respect to THE and the circle of stars	Remarks
219	Directly below center of "F"	Points to right of last star	"A" of AND points below "T" of IT
220	Directly below center of "F"	Points to right of last star	"A" of AND points to left foot of "M" of MUST
221	Directly below left center of "F"	Points to left foot of "T" of THE	
222	Points to space between "E" of THE & "F" of FEDERAL	Points to left foot of "T" of THE	Die break at foot of "T" of THE. 'E' of BE over 'Y'
223	Identical to 222		Error "BY" instead of "BE"
224	Points of space between "E" of THE & "F" of FEDERAL	Points to center of "T" of THE	
225	Directly below left side of first "E" of FEDERAL	Points to right of last star	
226	Directly below center of "F"	Points to right of last star	Stars at side of SHALL are very large with center consisting of two concentric circles.

* Adapted from Fuld, M. and G. The Numismatist 67:449 (1954)

TABLE XI

Key to Army & Navy in Wreath Dies — "Army & Navy" STRAIGHT

Dies 296 through 319

Die	Point of left sword handle	Point of right sword handle	Position of end of left top leaf	Position of end of right top leaf	Bow shape	Remarks
296	Near left serif of N	Near right side of Y	Slightly to right of A	Over right serif of Y	Open, downward to right	No bow ends
297	Below left serif of N	Slightly to right side of Y	To left center of R	Over right side of M	Closed, downward to left	Sword handles touch leaves
298	To left of N	Below center of Y	Between RM	Over right side of M	Open, slightly downward to left	Sword handles touch leaves
298A	To left of N	Below center of Y	Between RM	Over right side of M	Open, slightly downward to left	Virtually identical to 298, but with lower relief border and denticles
299	Below left center of N	Below left side of Y	Over center of R	Between MY	Small, no slope	Sword handles merge with leaves
300	Below right side of N	Below center of Y	Over left side of R	Over right side of M	Medium, no slope	Star between wreath
301	To right of center of N	Below left side of Y	Over left side of R	Over right side of M	Small, no slope	Star between wreath

Table XI — Continued

Die	Point of left sword handle	Point of right sword handle	Position of end of left top leaf	Position of end of right top leaf	Bow shape	Remarks
302	Below right side of N	Below center of Y	Over left side of R	Over right side of M	Medium, no slope	Ends of wreath almost invisible, star
303	Below left side of N	Slightly to right of Y	Over center of R	Between MY	Medium, downward to left	Small star between wreath
304	Below right side of N	Slightly to left of Y	Over left side of R	Slightly to right of center of M	Small, no slope	Crudely struck
305	No swords	No swords	Over left side of R	Over left side of Y	Double bow	Small star
306	Below left side of N	Slightly to right of Y	Over left side of M	Over right side of M	Medium, slightly to left	Sword handle just touches leaves
307	To left of center of N	Slightly to right of Y	Over left side of R	Between MY	Small, slightly to left	Very small sword handles
308	Far to left of N	To right of Y	Over center of R	Over center of M	Large, slightly to left	3 leaves on end of left top of wreath
309	Far to left of N	Far to right of Y	Over center of R	Over center of M	Open, downward to left	

Table XI — Continued

Die	Point of left sword handle	Point of right sword handle	Position of end of left top leaf	Position of end of right top leaf	Bow shape	Remarks
310	To left of N	To right of Y	Over center of R	To left of center of M	Open, slightly downward to left	Wreath very close to inscription
311	Sword handles turned upwards		Over center of R	Over center of M	Double bow	ARMY and NAVY slightly curved
312	Below left serif of N	To right of Y	To right center of R	To right center of M	Medium, open downwards to left	
313	Below left serif of N	Slightly to right of Y	Over center of R	Over center of M	Medium, downward to left	Left top of wreath has 2 leaves
314	Slightly to left of N	To right of Y	Over left center of R	Over center of M	Closed, downward to left	
315	To left of N	To right of Y	Over center of R	Over right center of M	Medium, downward to left	Right sword handle merges with leaves
316	To left and even with base of N	To right and even with base of Y	Over center of R	Over left side of M	Large, downward to left	

Table XI — Continued

Die	Point of left sword handle	Point of right sword handle	Position of end of left top leaf	Position of end of right top leaf	Bow shape	Remarks
317	To left of N	Right of Y	Over left side of R	Over center of M	Large, downward to left	
318	Below center of N	Below center of Y	To right side of R	To right side of M	Very small, no slope	
319	To left of center of N	To right of center of Y	To right side of R	To right of center of M	Medium, downward to left	

TABLE XII*

Key to "Army and Navy" dies — all dies have "Army and Navy" CURVED with star between wreath. Dies 320 through 329

Die	Wreath Description	Remarks
320	Left side of wreath has eight berries. Right side has eight acorns	Long prominent ray points to left side of "M" of Army, small ring on anchor
321	Left side of wreath has eight berries. Right side has eight acorns	Left side of wreath made of oak leaves, being different from any others in series
322	Wreath has no berries	Long, prominent ray from star points to right side of "R" of Army
323	Left side of wreath contains eight berries. Right side has no acorns	Anchor rope shows at juncture between wreaths. Prominent ray points between "RM" of Army
324	Left side of wreath contains six berries. Right side has no acorns	Anchor rope shows at juncture between wreaths
325	Wreath has no berries	No prominent ray at star. Ring of anchor very eccentric shape, similar to egg on side
326	Wreath has no berries	Long, prominent ray from star points to upper right arch of the "M" of Army
327	Wreath has no berries	Anchor rope shows at juncture between wreaths. Die break from base of "Y" of Navy to sword handle
328	Left side of wreath contains ten berries. Right side has ten acorns	Anchor rope shows at juncture between wreaths

* Adapted from Fuld, M. and G. The Numismatist 67:449 (1954)

TABLE XIII

Key to "Not One Cent" reverses. Dies 354 through 385

Die	Position of left side of N of NOT	NOT with or without serifs	Number of berries in wreath Left side	Right side	Position of berry near C of CENT	Position of berry near base of T of CENT	Remarks
354	Left side of O	With	No berries				Star rather than bow joining wreath
355	To left of center of O	Without	10	9	Even with base	Even with base	
356	Over center of O	With	8	8	Almost even with top	Slightly above base	
357	To right side of O	With	7	6	Almost to center	Almost to center	
358	Between O and N	With	10	10	Even with top	Below base	
359	Between O and N	With	10	10	Slightly above bottom	Even with base	
360	To right side of O	With	10	10	$1/3$ up side	Slightly above base	
361	Between O and N	With	8	8	$2/3$ up side	Almost to center	H just above bow
362	Between O and N	With	8	10	Even with bottom	$2/3$ up side	JGW below CENT
363	To left of N	With	8	8	$2/3$ up side	Even with top	Diamond below CENT

TABLE XIII — Continued

Die	Position of left side of N of NOT	NOT with or without serifs	Number of berries in wreath Left side	Right side	Position of berry near C of CENT	Position of berry near base of T of CENT	Remarks
364	To right side of N	With	8	8	Slightly over ½ up side	⅔ up side	Eagle's head below CENT
365	To left of center of O	Without	No berries				E far from wreath
366	To left of center of O	Without	No berries				E almost touches wreath
367	To right of center of O	With	No berries				NOT large, O is oval
368	To right side of O	With	No berries				NOT large, O is round
369	To right side of O	With	No berries				CENT in smaller letters than ONE
370	To right side of O	With	No berries				NOT far below wreath ends
371	To right side of O	With	No berries				NOT close to wreath ends
372	To right side of O	With	No berries				T of NOT almost touches wreath

TABLE XIII — Continued

Die	Position of left side of N of NOT	NOT with or without serifs	Number of berries in wreath Left side	Right side	Position of berry near C of CENT	Position of berry near base of T of CENT	Remarks
373		With	No berries				NOT very high between ends of wreath
374	To far right side of O	Without	7	6	Even with center	None	Star below CENT: star between wreath ends
375	Between O and N	Without	34 total	no bow	Even with center	Slightly above bottom	1863 below CENT, berry between OT of NOT
375A	To far right of O	Without	36 total	no bow	Even with bottom	1/3 up side	1863 below CENT; berry above T of NOT
376	To right of O	With	28 total	no bow	One even with top due below bottom	Slightly below top	E.S. below CENT
377	To right of O	Without	32 total	no bow	1/3 up side	Even with center	L. ROLOFF below CENT. L beneath right side of C

TABLE XIII — Continued

Die	Position of left side of N of NOT	NOT with or without serifs	Number of berries in wreath — Left side	Right side	Position of berry near C of CENT	Position of berry near base of T of CENT	Remarks
378	Between ON	With	32 total	no bow	½ up side	⅔ up side	L. ROLOFF below CENT. L beneath left side of E
379	To right of O	Without	32 total	no bow	Even with bottom	Almost touches die break from base of T	
380	To right of O	Without	32 total	no bow	⅔ up side, slightly below bottom	Even with bottom, even with top	
381	To center of O	Without	44 total	no bow	Even with center	Even with center	
382	To right of O	Without	32 total	no bow	Even with center	Even with base	
383		Without	4	3	Even with bottom	Very near base	Shield below CENT
384	To center of O	With	32 total	no bow	⅓ up side	⅔ up side	Four stars in triangle below CENT
385	To right of center of O	With	No berries				Very crude die, no bow

TABLE XIV*

Key to "Dix" Token Reverses. Dies 408 through 416

Die	Outer Circle	Position of S of SHOOT below ATTEMPT	Position of T of SPOT above IT	Position of H of HIM
408	Yes	S below AT	T slightly above T of IT	To right of S of ATTEMPTS
409	Yes	S slightly to right of first T	T slightly below T of IT	To left of T of TO
410	Yes	S below A	T between I & T of IT	Between S of ATTEMPTS and T of TO
411	Yes	S slightly to left of first T	T opposite I of IT	Between S of ATTEMPTS and T of TO
412	Yes	S below A Inner circle rope-like	T opposite T of IT	Below T of TO
413	Yes	S below A	T slightly below T of IT	Below T of TO

Almost identical to 412. Inner circle denticles not rope-like

Die	Outer Circle	Position of S of SHOOT below ATTEMPT	Position of T of SPOT above IT	Position of H of HIM
413A	Yes	S slightly to right of first T See Plate XXII	T opposite D of DOWN	Below T of TO
414	Yes	S slightly to right of A Die reads SPOOT	T opposite R of TEAR	Slightly to right of S of ATTEMPTS
415	No	S slightly to left of A	T between R of TEAR and I of IT	To left of T of TO
416	No	S slightly to right of A	T opposite I of IT	To right of T of TO

* We wish to thank Richard Picker for help in assembling this table.